ALSO BY R. O. BLECHMAN

————————————

Talking Lines

Franklin the Fly

The Book of Jonah

The Life of Saint Nicholas

Tutto Esaurito

Behind the Lines

Onion Soup & Other Fables

No!

The Juggler of Our Lady

Dear James

LETTERS TO A YOUNG ILLUSTRATOR

R. O. Blechman

Simon & Schuster • *New York London Toronto Sydney*

Simon & Schuster
1230 Avenue of the Americas
New York, NY 10020

First Simon & Schuster hardcover edition October 2009

SIMON & SCHUSTER and colophon are trademarks of Simon
& Schuster, Inc.

For information about special discounts for bulk purchases,
please contact Simon & Schuster Special Sales at 1-866-506-1949
or business@simonandschuster.com.

The Simon & Schuster Speakers Bureau can bring authors to your live
event. For more information or to book an event, contact the Simon &
Schuster Speakers Bureau at 1-866-248-3049 or visit our website at www
.simonspeakers.com.

Designed by Jaime Putorti

Manufactured in the United States of America

10 9 8 7 6 5 4 3 2 1

Library of Congress Cataloging-in-Publication Data

Blechman, R. O. (Oscar Robert), date.
 Dear James : letters to a young illustrator / R. O. Blechman.
 p. cm.
1. Blechman, R. O. (Oscar Robert), date—Written works. 2. Commercial
art—Vocational guidance. I. Title. II. Title: Letters to a young illustrator.

 N6537. B563A35 2009
 741.6—dc22

 2009005061

ISBN 978-1-4391-3687-4
ISBN 978-1-4391-4874-7 (ebook)

To Max

Dear James

January 20, 1984

Dear James,

Before commenting on the drawings you were kind enough to send me (or foolish enough—my tremulous line can sometimes cut and draw blood), I feel compelled to comment on your name. James. That speaks well for you. You've resisted the dreadful trend of reducing a perfectly good name to a sound bite. In going against the contemporary grain, in avoiding the crowd of Bobs and Bills, Tims and Toms, you have taken a different path than most people, and that is a good sign. All art worthy of its name has a counter look, has taken an errant path, one that others have not as yet taken—a path that a James might tread.

You write that you would like to become a professional illustrator. Beware. Your work will ultimately not be judged by your peers. It's an editor, not an art director, who wields the almighty thumb in the savage arena of journalism. And editors are not noted for their visual taste. In the relationship of editors to art directors, the latter are invariably the junior

partners. The very title, *illustrator,* implies the rank of the image. An image serves the text, it merely "illustrates" it. (A curious reversal of these roles occurred in the late 19th, early 20th centuries with the Parisian art dealer and publisher Ambroise Vollard. He often commissioned artists to provide visuals, then hired writers for the texts.)

A while back I wrote of the unequal relationship between writer and illustrator, and I can do no better than to repeat myself. If a text read, "'Bill kissed Sally in the hammock as it swayed gently between the hemlocks,' the illustrator's job was to strictly render Bill kissing Sally in the hammock as it swayed gently (not vigorously!) between the hemlocks (not pines!). It was not for illustration to aspire to the status of literature, as Anton Chekhov described it: 'The moon reflected in a piece of glass at the bottom of a stream.' Illustration was the moon, period. Or the glass, period. Nothing less, and nothing more—no reflections, no distortions."

That has changed. In the mid-fifties, a revolution occurred and a new word entered the vocabulary of commercial art. *Concept.* Illustrators asked themselves, "What's the idea behind the text? How can we express an idea, and express it in a novel, and maybe

even a startling way, that will expand, or comment upon the text?" In jazz parlance, a theme had become the occasion for a riff. Pranksters with our pens, we had become so many Charlie Parkers.

But the change was not entirely good. Our gain was also a loss.

The literal approach to text implied a literalness of technique and a high level of draftsmanship. There was great value in something well observed and carefully delineated. If the head and heart were often absent, there was something to be said for the presence of a hand.

Now, James, I have to pause and take a deep breath. It occurs to me that I've done everything except what you wanted me to do. Talk about your work. So I will answer your question. Finally. Let me say, as an overall comment, without going into details and very simply, that I like your work. I like its modesty. I like what's not said that doesn't need to be said. You get your ideas across with just enough to feed the eye as well as the mind. You draw a jacket and there are no buttons, no cuffs, no collar—but there it is: a jacket that reads as a jacket, and satisfies as a drawing. Its simplicity shows respect for the viewer. You don't give more than what the mind

needs, nor less than what the eye deserves. So bravo! Let's see more.

A final word. If you send your work to the magazines, you may be in for a shock. You may get a rejection note. The worst kind. A printed form. And probably you will be shattered. Shattered. We artists are hypersensitive, or we wouldn't be—couldn't be—artists. But don't, for God's sake, do what I once did—try to find out if the signatures are real. They won't be. I used to get rejection slips from *The New Yorker,* but stubborn, or silly, me, I kept sending them stuff. Although once—hallelujah!—I did receive a letter, a real one with a genuine signature. At least it *looked* genuine. I wasn't sure. So I gave it what I call the spittle test. I licked my finger and ever-so-gently touched the edge of the signature. And it smudged! The *y* in *Geraghty* smudged! It was the real thing! The art director of *The New Yorker,* William Geraghty (or Geraght), had written twenty-three-year-old me to say that I should send him more work. Of course I didn't. Why tempt fate when I had taken such a notable step up the career ladder?

But you may not get letters signed by art directors. You probably will get printed rejection slips. And as I've said, you will be shattered. It may have been the

THE
NEW YORKER
25 WEST 43RD STREET
NEW YORK, N.Y 10036

OXFORD 5-1414

We regret that we are
unable to use the enclosed
material. Thank you for
giving us the opportunity
to consider it.

THE EDITORS

I

Look what escaped my trash basket!

third or fourth or thirteenth or fourteenth rejection slip that you've received, and you will think, *No, I'm not going to waste any more twenty-cent stamps* (twenty times *two*! There are all those self-addressed and stamped return envelopes), *so I will not send out any more drawings.*

So don't. You can send them to me. But not right away. I have a crazy deadline that will keep me busy for another few weeks. And then you can send me more of your drawings. It's not only your name I like. I like your work.

Best wishes,
R. O. Blechman

February 8, 1984

Dear James,

I'm sorry to learn that you're thinking of leaving your job. If I were you, I would not do it. At least not right away. I realize that it's boring, and often silly, and sometimes demeaning, and many times frustrating (the levels you have to go through to get something accepted . . . !). And who does finally present your work to the client? An account executive. His main function is to keep the client happy—not you, the copywriter, and not your creative twin the art director, but the client, whose feet would never get wet unless somebody else hadn't first tested the water.

I know these things because I got to know them firsthand. Did you know that I was an art director for one silly year of my life? My boss was a guy who kept imploring me, "Bob, make it gross! Please! Gross!" (I swear it happened.)

But think of the advantages you now have, not just of the drawbacks. Every week or two, you get a salary that will pay for your rent, your dinners, your films,

7

your concerts, and, most important of all, for the pens and pads and paints you'll need for your *real* work.

You will also be freed of the grinding anxiety of worrying about when you'll see your next check. But there's a better reason to keep your job (and parenthetically, while I think of it, I want to say that the sillier you find the work, the freer you'll be, and the freer you are, the more original you'll be; not a bad thing). Now, the better reason to keep your job is that when you're not working on your art—when you're not thinking about it—your *unconscious* will be working on it. A great deal of A. E. Houseman's poetry was composed when he was away from his desk. He habitually took a stroll for two or three hours a day. It was then, he remarked, that "sometimes a line or two of verse, sometimes a whole stanza at once," would spring into his mind. Montaigne also found that many of his ideas occurred when he was away from his worktable. However, he complained, his best ideas came when he was on horseback, far from quill and parchment. You'll find, James, that when you're most relaxed, which is to say the least self-conscious, you'll be your most creative.

Think of dance. If you worry too much about the steps, you'll end up like the centipede when he was

asked, "How in the world do you move all those legs?" The centipede was stumped. It was only when he forgot the question that he was able to move.

I speak some French. I speak it best when I forget that I'm speaking the language but rather, speaking to somebody who happens to be French. Otherwise I'm in danger of becoming like the centipede. All tied up.

Consider Georges Simenon, perhaps the most prolific writer who ever lived. He managed to write 84 detective novels and 130 other kinds of books, and used nearly 24 pen names. If you think that's the only record he achieved, just think of this. By his own account—at least this is what he recorded in his memoir, *Quand J'étais vieux*—he bedded 20,000 women (he later revised it to 10,000). And he still had time to write? However, his ex-wife claims that it was more like 1,200 women. "[We] worked it out ourselves," she said. "I suppose if you chase after it like a rabbit, anything is possible . . . !"

Don't imagine that Simenon worked on a strict daily schedule. Far from it. In an entire year, no more than two months were devoted to writing. But his unconscious was at work. After several months away from his desk, he would get an idea, go to his study,

lock the door, take out his typewriter, and two or three weeks later he would emerge—with a loud *Ooooph* and a long manuscript.

Guilt also contributed to his extraordinary productivity. The guilt of not doing, for such long periods, what he so desperately wanted to do. In fairness to Simenon's phenomenal output, it must be mentioned that he had other incentives to account for his hyper-productivity. Married three times, he had hefty alimonies to pay. He also had hefty expenses. He built a 26-room château on the banks of Lake Geneva, owned 5 cars, and amassed a vast collection of paintings including several Picassos, Légers, and Vlamincks. As if those were not sufficient motives to write, Simenon also signed contracts committing himself to several books a year. But above all, I believe, he wrote much, and he wrote well, because he wrote fitfully.

Finally—because I'll run out of paper if I don't stop—let me quote Hemingway, writing as a young man in Paris. "I knew . . . that I must write a novel. I would put it off until I could not help doing it. I was damned if I would write one because it was what I should do if we were to eat regularly. When I had to write it, then it would be the only thing to do and there would be no choice. Let the pressure build."

Let the pressure build. And at 28. . . 38 . . . or whatever-8—everybody has his own time clock and some of them keep crazy time—the story, the poem, the painting, the drawing will burst out.

So don't quit your job. Not yet. Write copy, and write it well. And then go home, pour yourself a drink, take off your shoes, and if you feel like it (and only if you feel like it), draw. Let your unconscious—your freer, better mind—do its work. Your drawing will be the richer for it.

I look forward to your next letter—and I want it written on Young & Rubicam letterhead.

All best wishes,
R. O. Blechman

P.S. I just came across a dandy letter from the English poet Philip Larkin about his double career as a full-time librarian and part-time poet (and what a fine poet he is!). I can't resist quoting him.

". . . any 'artist' with a profession is bound to have an ambivalent attitude towards it: One loves it sometimes for the same reason. I don't think that, if one needs money, being an artist is sufficient excuse for shirking the job that feeds one, and I try to do mine conscientiously for that reason alone. . . . The best

thing to do is to try to be utterly schizoid about it all—
using each personality as a refuge from the other."

I love that part about each being "a refuge from
the other." What a wonderful rationale for not being a
full-time artist.

February 18, 1984

Dear James,

It may be a small matter, but I want to comment on something you may never have thought of as part of your drawing. Your signature. It should be as carefully considered as anything else you put your pen to. How it looks, and where it's placed, are important to the drawing's overall design.

Look at the work of Saul Steinberg—and I could refer you to any number of other artists. You'll see how he uses his signature as an integral element of the drawing. At times he won't even sign his last name. He'll use only the first letters, ST. And he'll place it horizontally, diagonally, midway in the drawing, underlined, undated, and if dated, abbreviated or unabbreviated. His eye, and his eye alone, dictated how his signature had to look and where it was to sit.

In the beginning of his career, he probably signed his drawings the way he signed his letters and checks. I should know. I once had occasion to hear from him. It was 1947. I was a seventeen-year-old college

freshman, with all the naïveté and presumption of a teenager. Having long admired his cartoons in the New York newspaper, *PM*, I wrote to ask him for a drawing, "inscribed to me, please." As it happened, it was several months before I received an answer. Intervening were *Mrs. Dalloway*, the foreign policy of John Quincy Adams, and slide lectures in Fine Arts 101, where a flustered Professor Clapp once hastily withdrew his pointer from Nike's left breast. Then, quite unexpectedly, a package arrived. It came without a return address, and the handwriting was unfamiliar. It was studied, almost calligraphic, vaguely foreign.

Opening the package, I saw that it was the answer to my presumptuous request: a drawing from Saul Steinberg—a Victorian grande dame, all ribbons and flourishes, with a curlicued inscription to match. It was years later that I thought about that signature. It had no relationship to the handwriting on the package. One was strictly functional. The other was art. Years later, Steinberg closed the gap, and his signature and handwriting became one artful statement.

A signature may appear to be a small matter. And in the grand scheme of things it is. But now I'd like to write about a large matter—a very large one. Your career. You write that your pen seems to wander from

the drawing board to the writing desk. And this worries you. You feel that you're not sufficiently committed to art, and you cite Rilke, quoting his remark to an aspiring poet, "Ask yourself in the most silent hour of your night: *Must* I write?" I feel sorry for the poor recipient of Rilke's letter. Suppose he would merely *like* to write, but cannot in all honesty say that he *must* write. Would he then feel disqualified to put pen to paper?

I believe that Rilke set up an unrealistic standard, and a highly dangerous one. How can a youngster full-to-bursting with ideas and emotions of the most varied and intense sort know with any certainty how they can be expressed? Talent is not always narrowly focused. Did a Leonardo know that he *must* either write or paint or invent? That he *must* do either this or that, when he needed to do this *and* that *and* that *and* that? Did Rubens, a diplomat from the court of Flanders and a painter to the princes of Europe, have to choose between careers? Or, to cite a few of the more contemporary people who happily combined careers, is the writer Paul Bowles a musician, or is the musician Paul Bowles a writer? Did Wallace Stevens feel that he had to give up his life-long seat at the desk of the Hartford Accident and Insurance Company for

his poetry? Or William Carlos Williams and his pediatric practice in New Jersey? Williams combined his two loves and refused to abandon either:

"I had my typewriter in my office desk. All I needed to do was pull up the leaf to which it was fastened and I was ready to go. I worked at top speed. If a patient came in at the time I was in the middle of a sentence, bang would go the machine—I was a physician. When the patient left, up would come the machine. Finally, after eleven at night, when the last patient had been put to bed, I could always find the time to bang out ten or twelve pages."

Anton Chekhov, also a practicing doctor and writer, expressed his double life in a most charming manner. Here's an excerpt from a letter to a friend:

"I feel more contented and more satisfied when I realize that I have two professions, not one. Medicine is my lawful wife and literature my mistress. When I grow weary of one, I pass the night with the other. This may seem disorderly, but it is not dull, and besides, neither of them suffers from my infidelity."

Do you know the books of Ned Rorem? He's a composer who writes the most entertaining and brightly crafted gossip about the music scenes in Paris and New York, cities where he lived for many years. Rorem had this to say about his difficulty in choosing a career.

"It was a question of almost flipping a coin as to what I was going to be when I grew up—a composer or a writer or a poet or a dancer, or what have you."

And finally (because I don't want to turn this letter into an essay), what is one to make of Jean Cocteau, that self-described "poet, poet of the novel, poet of the theater, poet of the essay, poet of art, and poet of the film"? Francis Steegmuller lists Cocteau's activities as, among others, "poet, novelist, dramatist, cineast, draftsman, portraitist, muralist, designer of posters, pottery, tapestries, mosaics, neckties, costume jewelry, and objects executed in glass and other media including pipe cleaners."

You mention another remark of Rilke's, "Confess to yourself whether you would have to die if you were forbidden to write." Speaking for myself, I would not be a martyr for my art. If I were forbidden to draw, I would sing, dance, compose, play a piano, shoot a film, or write the Great American novel, play, short story, or poem. But I would not die. I would be like a river, blocked in one area, I would change course and create a new channel. The creative force is unstoppable.

Cyril Connolly, in his lovely and justly admired book *The Unquiet Grave*, dropped another blockbuster

on aspiring artists. "The true function of a writer," he declared, "is to produce a masterpiece." A masterpiece?! Since when isn't brilliant good enough? Since when isn't plain *good* acceptable? With a standard set that high, the world would have fewer artists and more clerks. His standard is one that few writers would accept, and one that Connolly himself, by the way, never managed to fulfill. One does not set out to create a masterpiece. One just sets out, that's all. And the landfall, be it barren desert or Cloud Cuckoo Land, is beyond one's knowledge.

Years ago I illustrated a monthly column for a long-established, no-longer-in-print magazine, *Theatre Arts*. Every month I delivered my drawings to a young editor, Rod MacArthur, bringing them to his posh East Side apartment. "Wonderful," he would exclaim, spreading them out on his long Biedermeier desk. "Hey, Bob, these are just wonderful!"

Many years later I learned that he was not just any old MacArthur, but J. Roderick MacArthur of the genius grants family. Which made me wonder, Why didn't he give this "wonderful" artist a grant? Not a Genius Grant (I know my limitations), but something on the order of a Brilliant Grant, or even a plain old Talented Grant. That would not have brought in the

usual big bucks, I realize. I might have gotten maybe a hundred thousand dollars. But I could manage.

I suppose that's an example of the awesome spread between fame and failure, rich and poor, new and old (which can be last month's trend), a spread with little or nothing in between, a spread that increasingly typifies our culture. It's a gap of all or nothing, a gap that's becoming, in fact, an abyss.

Maybe the Ancient Greeks had the last word on the subject. They declared, "The enemy of the good is the best."

Now I have to stop writing and get to a drawing. It's due tomorrow. It won't be a masterpiece, but I hope that it will end up as something good, or with luck, brilliant. But good, that's okay by me.

Best wishes,
R. O. Blechman

March 3, 1984

Dear James,

Good news! I'm delighted that you saw J.C. Suares at the *Times,* and that he asked you to do a spot for the Letters column. It's a small job, granted. Two or three inches is hardly any space to work with, but that doesn't matter. The important thing is to bring big ideas to that small space. Size is irrelevant.

A designer friend of mine once complained to Paul Rand, that extraordinary designer, "I'm not going to do any more book jackets. I'm beyond that now." Rand shrugged. "Not me. I do them all the time," he said. And what he *does* do are jackets (and brochures and flyers) that are nothing less than small monuments of design.

I'd like to give you a "studio tip" to consider before you begin your spot for the *Times.* When I get a small space job (or, for that matter, any job where I'm told the format), I make a photocopy of the entire page, leaving a blank space where my illustration goes. That way I get to see how my art fits into the overall

layout. Then I set my goal: to draw something that will jump off the page. I suppose it's a little like an actor in rehearsal who gets to "feel" the stage before the performance.

I like to follow the advice Jean-Jacques Rousseau was given before he entered an essay-writing contest. The subject was, "Has the progress of science and the arts contributed to corrupting morals, or improving them?" (That's such a typical French question! You might hear it posed at a lycée today. My children, who attended a lycée, probably did.) The advice given to Rousseau was, "take the side that no one else will." Rousseau did, and he won first prize. That's the sort of thing an illustrator must do: the unexpected, the contrary—the original, when you come down to it. It's the only way to do art that justifies its name.

Back to the *Times* art director, J.C. Suares. I like working with him.

He's an illustrator himself, not just a designer, so he has an understanding of the craft. Occasionally, when I hand in my finish, he'll ask for my sketches. And then he'll publish my sketch. And why not? It might have the freshness and vitality that were lost when I tightened up to draw the finish.

You'll find that getting a commission puts you

on the fast and easy track. You're given a format, a subject, and a deadline, so your boundaries are set. How much more difficult it is to self-start a project! You can get overwhelmed with possibilities, like a car whose engine is too flooded to start. The important thing, however, is to begin with something— with anything. That small beginning may grow miraculously. When I was a kid, I used to buy Japanese paper flowers, tight little paper pellets that I dropped into a glass of water. And then a miracle happened. That little pellet would fan out and blossom into a gorgeous pink- and purple-tipped flower. Ideas are sometimes like that—but not before they're put on paper. The essential thing is to commit oneself to an idea. An admirer of Goethe, W. H. Murray had this to say about the importance of beginning a project:

> "Until one is committed, there is the hesitancy, the chance to draw back, always ineffectiveness. Connecting all acts of initiative (and creation), there is one elementary truth that ignorance of which kills countless ideas and splendid plans: that the moment one definitely commits oneself, then Providence moves, too."

Goethe himself wrote:

"Whatever you can do or dream you can, begin it.
Boldness has genius, power, and magic in it."

Starting a project is rarely easy. Take it from the master essayist, E. B. White, who says, "Before I start to write, I always treat myself to a nice dry martini. Just one. To give me the courage to get started. After that, I am on my own."

Other writers have different stratagems to jump-start work, and let me tell you, some of them are downright bizarre: dipping feet into hot water (Turgenev), drinking noxious quantities of black coffee (Balzac), and smelling rotten apples (Schiller). Choose your own method— it can be as benign as sharpening pencils or cleaning your desk—but the essential thing is to get started, to put pen to paper, to allow Goethe's "Providence" to move into action.

Sometimes what will turn up after long hours— or days or weeks or, if a novelist (poor wretches!), years—of work will be . . . nonsense. And then one must overcome the pain and frustration—and worse, the self-doubt—and begin work again. But sometimes what seems to be nonsense has its value. Dostoevsky

thought so. In *Crime and Punishment*, the protagonist's friend, Razumikhin, had this to say (it's too long to paraphrase, so I'll just quote directly).

"Do you think," Razumikhin cried out, raising his voice still higher, "do you think I care if they talk nonsense? Hogwash! I love nonsense! Talking nonsense is man's only privilege that distinguishes him from all other organisms. If you keep talking big nonsense, you will get to sense! I am a man and therefore I talk nonsense. Nobody ever got to a single truth without talking nonsense fourteen times first. Maybe even a hundred and fourteen. That's all right in its own way. We don't even know how to talk nonsense intelligently, though! If you're going to give me big nonsense, better make it your own big nonsense, and I'll kiss you for it. Talk nonsense in your own way. That's almost better than talking sense in somebody else's. In the first case, you're a man; in the second just a parrot! Sense will always be there, but life can be fenced in. There have been some sad cases. Well, what about us now? We are all—without exception, I tell you, in science, thought, culture, engineering, ideals, aspirations, in our liberalism, reason, experience, everything,

everything, everything, everything, everything—we
still sit in the freshman class in high school! We
would rather live off other people's ideas—that's
what we're used to! Not so? Isn't what I'm say-
ing really so?" Razumikhin shouted, shaking and
squeezing both ladies' hands, *"Isn't it so?"*

"Gracious, I don't know," said poor Pulcheria
Alexandrovna.

Poor Pulcheria Alexandrovna, indeed, to have been
assaulted with such passion!

The novelist and essayist Arthur Koestler (who,
incidentally, wrote that "without both outlets [he]
would feel only half alive") maintains "the creative
act [is] untouched by the dogmas and taboos of so-
called common sense." In other words, creativity is
a by-product of *non*-sense, not of "so-called common
sense." Nonsense "[as] in the dream, the revery, the
magic flights of thought, when the stream of ideation
is free to drift . . ."

Most new discoveries are initially treated as non-
sense. They challenge the existing order and those
who profit from it. When the 19th-century scientist
J. J. Waterston wrote his landmark treatise on the
molecular theory of gases, it was dismissed out of

hand by the referee of the Royal Society. "The paper is nothing but nonsense," he remarked. It took nearly half a century for the paper's revolutionary findings to be recognized.

Ignaz Semmelweis was an assistant at the General Hospital in Vienna. During his tenure, childbirth fever claimed the lives of one out of every eight women. Semmelweis observed that surgeons and students often treated women after handling cadavers. In 1847 he declared that improper hygiene was the cause of the high death rate. He started the practice in his ward of washing hands in chlorinated lime water before treating women patients. Within a year the mortality rate in his ward plunged from one out of eight women to one out of a hundred. "Semmelweis's reward," as noted by Arthur Koestler, "was to be hounded out of Vienna by the medical profession"— motivated as much by stupidity as by resentment of the suggestion that medical professionals might be carrying death on their hands. Semmelweis went to Budapest, but he made little headway with his colleagues and denounced them as murderers, became raving mad and was put into a restraining jacket. He died in a mental hospital.

Semmelweis may have encountered more than

stupidity and professional jealousy during his life-time. He was a Jew in Austria, where anti-semitism was a national virus. (Austria was "enemy territory," according to the scholar Victor Klemperer.) Jews were commonly banned from such professions as teaching and law. Driven to "permitted" professions, Jews became prominent in the arts, especially in journalism, theater, and publishing. Nursing their cups of *kaffee mit sahne,* the coffeehouses of Vienna—those cosmopolitan centers of wit and intellectual banter—saw such regulars as the Jewish writers Stefan Zweig and Franz Werfel, Robert Musil and Arthur Schnitzler. There they sharpened their wits and shaped their ideas. But before Semmelweis could join their exalted circle, his white doctor's coat was exchanged for a straitjacket.

In 1848, Charles Darwin's landmark paper on the origin of species was read to the Royal Society. However, in his annual report, the Society president wrote, "The year which has passed . . . has not, indeed, been marked by any of those striking discoveries which at once revolutionize, so to speak, the department of science on which they bear." It took the publication of Darwin's *On the Origin of Species* for the storm to break, a storm that has not yet subsided. What if the

book had *not* been published? What if Darwin had been so intimidated by the president of the Royal Society and the prevailing worldview that he did not publish his findings? Would he have joined the countless other rebels, unknown and anonymous, whose discoveries were denounced and ignored as nothing but nonsense?

It's the nonsensical ideas—the crazy ones, or so they seem to be at first—the ideas that don't have the most logical and obvious connections—these are the ideas that, when visualized, jump off the page with a punch. "Tell a lie," Francis Bacon declared, "and find the truth." Lies, nonsense, seeming errors— these are what lead to the freshest and brashest and brightest solutions. Thomas Kepler, who first revealed the planets' elliptical orbits, maintained, "Errors are going to be our path to the truth." Errors are merely cul-de-sacs in a labyrinth. And every labyrinth, after the many false and frustrating paths, leads to an opening.

Toward the end of the Second World War, Ben Shahn wanted to illustrate the tragedy of war. He could have painted the obvious: a pile of corpses. Instead, he painted a single body—a soldier lying on a beach, his body virtually lost among thousands and

thousands of minutely rendered pebbles. The viewer's eyes first takes in the pebbles, but then—with a start—a body. That surprise, that shock, is what gives the painting its emotional impact. Ben Shahn's seemingly illogical solution turned out to be the most effective (and affective) one.

Preliminary drawings and sketches often are discouraging things, pale shadows of one's bold intentions. Seemingly nonsense, they're especially dispiriting for beginners who don't have a history of success to embolden them to explore an idea further. "Is that what I did," the novice might ask, "and I consider myself an *artist*?!" Abandonment of a project, or of a career, too often follows.

Even established artists and writers go through periods of crippling self-doubt. At the risk, James, of turning this letter into a book of quotations, let me quote T. S. Eliot writing about what he elsewhere called, "the pains of turning blood into ink."

> So here I am, in the middle way, having had
> twenty years—
> Twenty years largely wasted, the years of l'entre
> deux guerres—
> Trying to learn to use words, and every attempt

Is a wholly new start, and a different kind of
 failure
Because one has only learnt to get the better of
 words
For the thing one no longer has to say, or the way
 in which
One is no longer disposed to say it. And so each
 venture
Is a new beginning, a raid on the inarticulate
With shabby equipment always deteriorating
In the general mess of imprecision of feeling,
Undisciplined squads of emotion . . .

T. S. Eliot was something of a social wallflower. Lady Ottoline Morrell, commenting on his behavior as a dinner guest, wrote in her diary, "He never moves his lips. I felt him monotonous without and within . . . he was dull, dull, dull." But it was this very dullness that spurred him to create that masterly portrait of J. Alfred Prufrock (a self-portrait, of course), who lamented, "I should have been a pair of ragged claws/Scuttling across the floors of silent seas." In the choice between a rich personal life and a rich creative one, there's little doubt which one Eliot would have preferred (but there rarely is a choice, is there?).

Eliot's pen was his mouthpiece, his Cyrano de Berg-erac who spoke for him. It's rare to find the artist whose tongue is as eloquent as the pen. One usually compensates for the other.

Speaking for myself (but also for other illustra-tors, I'm sure), my trash basket is full of false starts and failed beginnings. Only after much work does a drawing become right. Listen to that master cartoon-ist Peter Arno, as he talks of the incredibly hard work that goes into a seemingly spontaneous drawing. (One can almost hear the *ping, ping, ping* of sweat dripping on his worktable.)

It's a long tough grind, with endless penciling, eras-ing, rectifying, to recapture the effect and mood pro-duced in the original rough. This penciling is the invisible framework that's later erased so the viewer will never suspect it was there—the labor and sweat which enable it to look as if no labor or sweat was spent on it. . . . Sometimes this pencil layout won't come out right, no matter how I wrestle with it. It lacks the life and movement it should have. When this happens I start all over again on a new piece of gleaming white board. Sometimes I make five or six beginnings, reworking faces and postures,

striving for the exact comic quality the idea calls for. . . . But finally I think I've hit it, and am ready to continue. . . . Now you—let's suppose here that you're the artist—you dip a fine-pointed sable brush into India ink and start laying in the heavy black strokes that will be the skeleton of your drawing. You keep the line rough, jagged, spontaneous-looking. That's your god (or mine): spontaneity. You move fast, with immense nervous tension, encouraging the accidentals that will add flavor to the finished drawing. . . . When the ink is dry, if it still looks right to you, you start that awfullest of chores, the erasing of the mass of penciling that lies beneath the ink, 'til nothing is left on the board but crisp, clean, black-and-white . . .

I once came across a book of Arno's cartoons inscribed to a lady friend, "In memory of that unforgettable night in Capri" (or something of that sort—I no longer have the book). The inscription was pure Arno. But the drawing below it had no relationship to his work—had none of his confident devil-may-care boldness of his trademark style. Undoubtedly he was not going to bother with a pencil rough before committing himself to drawing on the book's flyleaf. And the result shows.

I think it's such a disservice to the public that galleries and museums display only artists' successes, but never their failures. There should be a Museum of Failed Art. It would exhibit all the terrible art that would have ended up in trash bins and garbage cans, lost and unknown to the public. My museum would give a true picture of the artist's life, and provide much consolation to fellow artists.

Now I'll leave you, finally, to your spot. When will it appear? But forget the question. I know those deadlines, those 24-hour-drop-dead turnarounds, so your drawing may have appeared before you receive this letter. I hope—I'm sure—it turned out well.

All best wishes,
R. O. Blechman

March 22, 1984

Dear James,

You ask for a photo of my studio, so all right, here it is. An Elizabethan castle high above Manhattan's 47th Street. I call it my Cold Water Castle because I never did get to install hot water in my office. The space was designed by Bertram Goodhue, an early 20th-century architect who managed to combine different styles in an absolutely unique way. His masterpiece may be Saint Bartholomew's on Park Avenue, although his skyscraper for Nebraska's State Capitol is a remarkable blend of Deco and neo-Gothic. I work in Goodhue's private room, overlooking a flower-filled terrace and, in the distance, the Empire State Building. Despite these views, I still manage to occasionally turn my eyes away from the window and down to my desk (although increasingly it's to write a letter or draft a memo or sign a check).

Working environments matter. Where an artist works determines to a great degree how well he works. Surroundings are a great stimulant. They can

inspire or depress a person (but if they depress, that also might be a spur to art). The important thing is that an environment move you, that it engenders a passionate state of mind—of hate or love or disgust or delight. Passion is the primary engine driving creativity. The enemy of art is indifference.

The castle I keep puts me in great artistic company (and acts as my creative spur). Rilke, that ultimate dandy, required the sumptuous elegance of Schloss Duino, perched high above the Adriatic, to compose his *Duino Elegies*. Mark Twain had a special octagonal room built for his writing, its broad windows overlooking a panoramic hillscape. Richard Wagner needed velvet and gold (he stroked plush red velvet as he composed), and the turrets and Alpine vistas of King Ludwig's fantasy castle, Neuschwanstein. Many artists, asserts the critic Clive James, "have to arrange their personal lives at a certain aesthetic level before they can function." He cites John Keats, who had to wear his finest clothes before putting pen to paper. Photographs of Little Nemo's creator, Winsor McKay, show him at work, Stetson atop head, cravat neatly tied.

Granted, there are notable exceptions. Clive James once met W. H. Auden at home, surprised to observe the condition of his tie. "I thought it had been

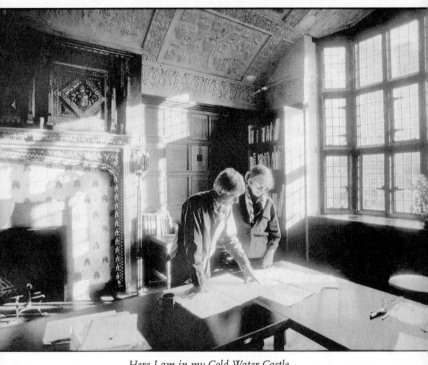

Here I am in my Cold Water Castle.
The lady is Tissa David, a genius animator.

presented by Jackson Pollock until I realized it was a plain tie plus food." No Keats, he.

Some people point to the first book I ever did as my best piece of work. Maybe so, maybe not (I hope "maybe not," since I did it as a 22-year-old). But what strikes me, more than half a century later, is that I did it on a food-stained, green Formica kitchen table in my parents' apartment. So much for the necessity of a stimulating environment! But I suppose that in this instance I wrote in *spite* of my environment, not helped by it, so strong was my impulse to create.

As you probably know, my studio produces animated films (I never call them *cartoons*. That's as much a misnomer for what my studio tries to do as the term "comic strips" for things as sublime and sophisticated as Krazy Kat). I've rarely embarked on a project without first getting a commission for it, so my output is limited. But waiting around for a commission is not the best way to get one. A person has to move around, to see people, to speak to them, and then— just maybe—something will happen, somebody will be interested in what you have to offer. It's the accidental encounter, the happenstance that moves a ball to those high-number bulbs in a pinball machine.

A case in point. I was in Milan a few years ago

for a television conference. I was sitting in my hotel lobby when in walked the program director of PBS. We greeted each other, then began to small talk.

SHE: "This hotel is so well located."

ME: "Right next to the Duomo." (*to myself: I hope it's called the Duomo!*)

SHE: "I loved your last program."

ME: "Thanks."

SHE: "Are you thinking of another?"

ME (FLUBBING IT): "Not really."

SHE (READY TO WALK AWAY. I COULD SENSE IT): "Well, if you think of another program, let me know. Enjoy Milan." (*She leaves.*)

ME (TO MYSELF): *Schmuck! What kind of answer was that?! You know you have a* million *ideas for programs. Two* million!

I left the lobby, sorry I had ever met her. That encounter was going to ruin my stay in Milan, absolutely *ruin* it!

Walking from the hotel, I happened to pass the La Scala Opera House.

My eye caught a poster for an upcoming production of *L'Histoire du Soldat*. I knew that piece—I knew it and I loved it, as I love all the music of Igor Stravinsky. An idea hit me, "Why not an animated version of *L'Histoire*?"

A day or so later, fate was kind. I came across the PBS program director again.

ME: Suzanne, I was thinking about your question, Did I have any thoughts about a program? It occurs to me that it would be great if there was an animated version of *L'Histoire du Soldat*.

SHE: I know that piece. I adore it. We did a performance of it at the Walker Art Center and it was a great success. Bob, send me a proposal and I'll pass it on.

ME (TO MYSELF): *Pass it on?! She's the program director of the Public Broadcasting System! Who's she going to pass it on to, President Reagan?*

But I dutifully wrote a proposal, sent it on, heard nothing, and forgot about it. A year later—*ding-a-ling!*—my phone rang and it was WGBH Boston calling. They had seen my proposal, and were interested in doing a special for the upcoming centenary of

Stravinsky's birth. *Ping!* I had struck a million-dollar bulb.

Now, if I had *not* been in Milan; if I had *not* met the program director of PBS in the hotel lobby where we happened to both be staying; if I had *not* passed La Scala; if I had *not* seen the poster, etc. etc. You get the picture. A dozen links made up that chain of co-incidences, and if just one link—just one—had been missing, that chain would have been broken.

Why do I mention these things? Because, James, we artists tend to be a silent, self-effacing lot, and become easily discouraged. I could have ignored the program director's undoubtedly pro forma request to send her a proposal, and the project would have been stillborn, right then and there. But it isn't. It's happening, and it seems to be going well ("seems to be." It will be, or it won't be, I'll know only when it's finished).

So when you're not at the agency, when you're not at your drawing table, *meet* people, talk to them (and listen to them! That's important, or they won't listen to you), and—*ping!*—You may strike that million-dollar bulb.

All the best,
R. O. Blechman

April 19, 1984

Dear James,

I know, I know, it must be about two months since I received your letter, and I haven't acknowledged it ("it" being buried beneath one of the many stacks of drawings, bills, memos, letters, books, and Herb Gardner's cartoon, "We've got to get organized"). But here it is: your acknowledgment and my apology.

The Chinese have a saying, "Be careful what you wish for. It just may come true." And the animated film I so devoutly wished for—that is, *this* kind of longer-length film (I've done what seems like a million of the other kinds: the commercials and the short subjects)—*this* kind is turning out to be a juggling act, and I'm no many-armed Hindu goddess. But I do have other people's superb hands, primarily the animators'—most of them, that is—and they often seem to draw better than I do (really!) and often compose whole scenes better than I could, or at least make suggestions that prove invaluable.

Do you know the work of Fred Mogubgub (that name is no put-on)? He's a brilliant animated filmmaker who combines live action and animation like no other filmmaker I know. He probably invented quick cutting (cutting from scene to scene by no more than a single frame, i.e., *1/24th* of a second). His film *Enter Hamlet* edits the image to the track of Hamlet's soliloquy, "To be or not to be," word by word. That's only one of his brilliant exercises (I predict a great career for Mogubgub). And then there's Tissa David, who restructures many of my scenes, and is invariably right. She's not merely an animator. She's an animated filmmaker. All the difference in the world! And there's Ed Smith, who takes my drawings and moves them fluidly and expressively. I couldn't make films without these animators. And when I have had to work with other animators, so many great beginnings ended badly; like the film *Abraham and Isaac,* with the gorgeous track by Pete Seeger. It was a bust, a painful miss, because the animation was so poor. My cutting and storyboarding were no great shakes, either!

I've just finished a scene in which the Devil and the soldier are competing at a card game. I pictured the characters as silhouettes, the Devil in solid red,

the soldier in solid black. No matter how hard I tried to get those drawings right—I redid and re-re-re-re-re-redid them—I could not get those drawings to work. Finally I ran out of time. I had to give the scene to the cameraman and move on to other work. But now I realize what the problem was. I drew them too large, to a scale that was not natural to me. I prefer to work small, and then, when necessary, have the drawings mechanically enlarged. But I didn't think of that at the time. Oh well, water (ink?) under the bridge! I'm not sure that I have the time now to redraw them. They've already been cut into the film, and I may not have the luxury of redrawing (or re-re-redrawing) them. Not before I finish other, more pressing work.

Damn! I should have known better. I should have looked at James McMullan's watercolors and learned from them. He renders his art very small, usually 5" by 7", and then has it enlarged for those gorgeous Lincoln Center Theater posters. And since I'm speaking of McMullan, pay attention to the abstract elements he incorporates into his posters: he adds the most contemporary graphic touches to his superb draftsmanlike renderings. And pay attention to his lettering. He traces typography, so that it has the warmth of handwriting combined with the precision

of typography. McMullan has to be one of the best watercolorists around (bar none). How many artists have the skill to move their watercolors from a blue into yellow without a transitional passage of green? Most artists wouldn't even attempt it.

Speaking of scale, check out the watercolors of Robert Andrew Parker. They're huge. That's the size most comfortable for him. Every beginning artist has the problem of finding an appropriate scale to work in, as well as a medium that feels right, and, the most difficult and elusive problem of all for a novice, a style that is personal. These are found over time, and only through trial and error.

What amazes me is how integral style and subject matter are to an artist—how they mesh so seamlessly—each supporting and enhancing the other. Take the work of James Thurber. His drawings were often done in pencil, barely touching the page, as if he was afraid of what might turn up. *The New Yorker* writer E. B. White often had to snatch them from Thurber's trash basket, uncrumple them, and draw over them in ink. On the other pole of daring, there's the swashbuckling linework of Peter Arno. The styles of both artists not only reveal the person behind the pen (or pencil), but sets us up for the drawing itself.

Before we even get to Thurber's punch line, we smile; with Arno, we snicker.

Before I forget (I'm so caught up with my own work these days!), I liked your drawing for *Money Magazine*. Good drawing, good idea. Beauty and concept, a happy (and necessary) marriage!

<div align="right">

All best wishes,
R. O. Blechman

</div>

May 1, 1984

Dear James,

That was a nice idea you came up with for *The Village Voice,* a garbage truck carrying the sign "We Work for a Cleaner New York," all the while spewing clouds of filth into the air. I would have liked the drawing better, however, if the fumes were drawn differently. Instead of the overall flat gray you used, which was something of a shortcut, I think you should have rendered the gritty dirt-laden trail of fumes by using a spatter technique. (A simple matter. Take a tooth-brush, dip the bristles in ink, and then rub it a few times over a kitchen strainer, which will create the spatter.) It's a technique that William Gropper used to great effect. I'm enclosing one of his drawings.

An old vaudeville act would have two men dressed in a horse's costume. One would be in front, the other in back. The two vaudevillians would then act in tandem. Illustration is like that. The idea is only one part of the "horse." The other is the rendering. They have to act in unison for the art to work.

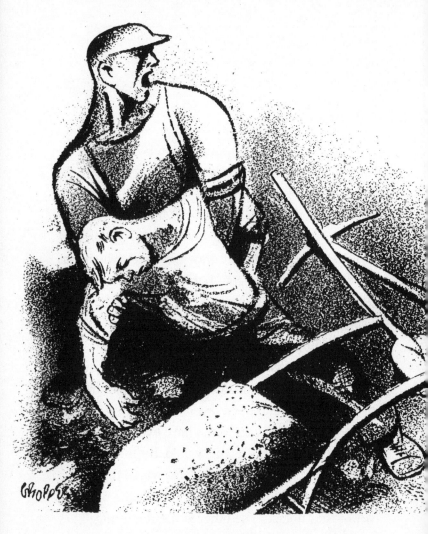

Spatter really pushes the power of this Gropper drawing.

At the present time, your drawing skills are not yet in step with your ideas. But look, you're young, you're new to the field, so you'll grow as you come to realize that you can't rely solely on the strength of your ideas to carry your art.

This is something I had to learn. At first—and for many years afterward—my drawings were terribly wooden. I came to realize that I had to develop a style that breathed. When I started out, I worked in several different styles—a cross-hatch, a tight line, a stitched line (an innovation of Ben Shahn's, incidentally, who had a great influence on illustrators in the 1950s. Andy Warhol, for example, when he first entered the illustration field, used a stitched line in his work for CBS and I. Miller Shoes), and, yes, in addition to these stylistic approaches, *I* used a shaky line. That last look was the direction I liked best, and that's what I chose to develop. So you see, it was something both natural and artificial. It was nothing I was fated to use. It was, rather, something I *preferred* to use.

I'm reminded of a story about Robert Frost's distinctive drawl. One day he looked in a mirror, saw a white-haired man returning his gaze, then said to himself, *Now . . . an old man . . . like the one . . . in that mirror there . . . he . . . would . . . speak . . .*

slooooooowly. And from that time on, that's how Robert Frost spoke.

Sometimes an illustrator will make the mistake of forsaking commercial art (to use the term that is so in disfavor in these euphemistic times. Now it's called communication art, God save us!), and turn to gallery art. The latter certainly has more prestige than the former; and, let's face it, there are no art directors, editors, and/or account executives to contend with (only the art market, which can be more inhibiting, but that's another story). So a Maxfield Parrish will turn to calendar art, literally and figuratively, and all the extraordinary twists and turns of his brush will be flattened out for those proverbial ladies in Dubuque.

There are exceptions. Occasionally an illustrator's move to gallery art can be successful. Look at Saul Steinberg. His transition to fine art was natural, an extension of his talent rather than an abrupt break with it. The wit, the charm, the ideas—none of these were abandoned as he moved from pen and ink to watercolor, collage, crayons, oils, etchings, lithographs, murals, 3-D constructions, etc. It was not as if he had said, *Now I will be an artist. Bye-bye cartooning.* No, Steinberg continued doing what he had always done. He continued to play. A grown-up kid, he just

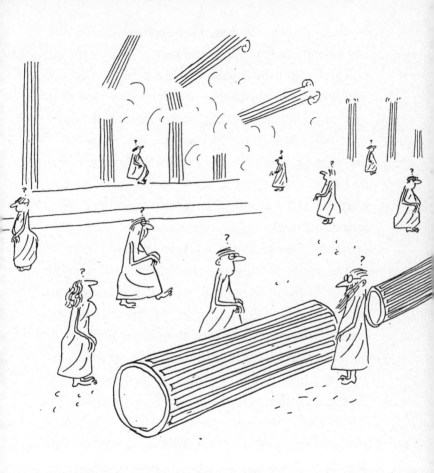

BY THE NEXT DAY NOT A BUILDING WAS LEFT STANDING.

My magnum opus as a 19-year-old.
The people are as stiff as columns.

took up one new medium after another, playing with one new toy after another. And that was his secret: He was always at play. Anything else can be the death of creativity. I spoke of Charles Darwin before. One commentator remarked that his scientific breakthroughs were possible because "it was with the sharp eye of the primitive [and] the open eye of the innocent, that he looked at his subject, daring to ask questions that his more learned and sophisticated colleagues could not have thought to ask." Ignorance—or at least "the open eye of the innocent"—has its virtues.

The move to different fields, from, say, graphic design to painting, radical as it is, can sometimes be successful. One of our great designers is Marvin Israel, formerly of *Seventeen* magazine, and now of *Harper's Bazaar*. He transitioned from editorial design to painting, and his work is quite remarkable (owing something to Francis Bacon, but with its own stamp). But Israel is an exception. A more typical case is André François, the compatriot of Romanian-born Steinberg. François's illustrations burst with energy and wit, but many of his canvases seem forced and self-conscious, lacking the endearing charm and wit that mark all his illustrations. I can't help thinking that he paints with one eye on his canvas, and his

other eye on the studio of Saul Steinberg three thousand miles away.

I must end this letter. Ida Greenberg, the studio checker, is at my door, hands on hips. "Where are the models for Scene 46?"

Yikes!

Hastily,
R. O. Blechman

May 22, 1984

Dear James,

I used to teach cartooning at the School of Visual Arts. One of the teaching aids I gave my students was a page with nine dots on it, arranged in rows of 3. Here it is.

 I would ask my students to connect the dots without lifting their pencils. Invariably, they would all connect

the dots while carefully staying within the boundaries of the outside dots. That was their assumption. But it was just that: an assumption. Who was to say that the lines had to be drawn through the *centers* of the dots? Nobody. It was just what one author called a "perceptual block." Making assumptions can be a hindrance to problem solving. For example, a common assumption is that an illustrator can't depart from the text. That's nonsense. What's important is only that the illustration relates to the subject matter, but not necessarily mimic the writer's point of view. For example, if some hack adopts our government's line and writes a glowing article on General Pinochet's regime in Chile—but the illustrator knows damn well that presumed activists are routinely imprisoned, tortured, and executed—then an artist has the following options:

One: Turn down the article (and kiss a few hundred dollars good-bye, and maybe some nice exposure)

Two: Illustrate the damned article with something that would not offend the author (but some of that check can go to Amnesty International, right?)

Three: Illustrate the article while sticking to the subject—and also sticking it to the writer.

Now option *three,* sticking it to the author, that's more fun—isn't it?—and more justified. And the illustration might just fly, especially if the newspaper has run out of time and the issue has to be put to bed. Of course, I have to confess, a more likely scenario would be that the artist would be told to please illustrate the article, or else another illustrator would be asked to do the work (in which case some of the cancellation fee which can *still* go to Amnesty International).

This is all brave stuff, I realize, James, because as we both know, *The New York Times* (or whomever) might just say, "Listen, I can't work with that guy! He'll give me a heart attack every time I call on him. Who needs it?!" That's the chance a contrarian takes, but keep in mind that contrarians tend to stand out from the crowd and get noticed—no bad thing.

I just illustrated an op-ed piece for *The New York Times* written by President Reagan. I drew a giant elephant, arms crossed, eyes closed, seated on a bunch of (presumably) Democrats. To my surprise, the damn thing ran! Of course when Easter came, I was not invited to the White House egg-rolling

ceremony, but I probably would not have been invited anyway.

"Doing your own thing," as the saying goes, is not just a matter of being able to live with one's conscience. It's a matter of having fun. And conceivably, of changing a few hearts and minds as well, although I do tend to agree with W. H. Auden, who wrote, "Poetry [or art] changes nothing."

Auden's statement might be the subject of another letter (my work on *L'Histoire* permitting), but I will simply say that a Thomas Nast cartoon *did* help to bring down Boss Tweed and his Tammany machine; and that Abraham Lincoln *did* acknowledge the power of Harriet Beecher Stowe, author of *Uncle Tom's Cabin*, by greeting her, "So you're the little lady who started this war!" So maybe, just maybe, some pens are powerful weapons.

But enough. It's fun and games to write you, James, but it's more fun and games—and (knock on wood) fame and profit—to work on my film, so I will break off this letter, but not before saying that you can send me more of your stuff. However, don't expect prompt answers. Not these days.

All the best,
R. O. Blechman

June 22, 1984

Dear James,

"When troubles come," Shakespeare wrote, "they come not singly but in legions." Well, James, the legions have come, all in uniforms of banknote green. And they have camped right at my castle door.

This week I discovered that the studio has run out of money. We have to stop work on *L'Histoire du Soldat*. Can you imagine? All along we've put our own money into the project to supplement what we've gotten from WGBH, the Corporation for Public Broadcasting, and PBS. But now I learn that our piggy bank is empty. I have to find money somehow, somewhere—and fast.

Yesterday I put in a call to Chloe Aaron, the director of programming for PBS, who had been so helpful in producing my last PBS program, *Simple Gifts*, a Christmas special. "Chloe," I implored her, "I've gotten so far into this project, I can't possibly stop now. I have to get about two or three hundred thousand to complete it. I must say that the film is really coming

along . . . looking really good. . . . We've got Max von Sydow to play the Devil. . . . And we've got a great voice for the soldier. . . . And yadda, yadda, yadda . . ."

"Bob," she replied, "I'll speak to Susan Lacey at Great Performances."

"No [sigh], don't. Don't bother. It's useless. I spoke to Great Performances last year. They turned me down."

Chloe, with a smile in her voice, "I'll speak to Susan."

Some people have the gift of gab, others don't. Early this week I received a check for $200,000.00. Just look at those zeroes. Every zero, a dream bubble. I went to the bank, deposited the check, returned to my studio . . . but couldn't open the door. It was locked. At ten in the morning? *Locked??* Then I noticed an envelope taped to the door. It was from the Motion Picture Screen Cartoonists Local 841. "Due to unpaid Employer Contributions to the Union's Pension and Welfare Fund dating from the 15th of August, the employees of the Ink Tank have been notified to strike. . . ."

Gone. All those zeroes—dream bubbles, indeed! Most of them just floated away, right into the pockets of the Pension and Welfare Fund of the Motion

Picture Screen Cartoonists Local 841. But enough money remained to reopen the doors—not wide, but just enough to resume production. The Goddess of Fortune had taken another turn on that ever-spinning globe of hers.

Sorry about this solipsistic letter. It's not a fair or thoughtful response to yours. But come to think about it, your last letter spoke a lot about your up-and-down relationship with Emily Gruber. So fair's fair. You talked about your love. Now I'm just talking about mine (a love affair that's just as up-and-down). But next letter we'll talk about the one love we share.

All best wishes,
R. O. Blechman

June 24, 1984

Dear James,

That's a tough question to answer. Where should your younger brother go to school? Okay, we know that Seth wants to be a painter, or illustrator, or graphic designer, or filmmaker, or all or several of the above. That's what we do know. What we *don't* know is what will give him the best grounding. An art school or a liberal arts college?

My inclination—and it's no more than that—is to recommend (and here goes a coin, flipped into the air, and landing on . . . heads!) . . . a liberal arts college. Here's why. Art, and especially illustration, relies heavily on metaphor and analogy for content. A deep foundation in the liberal arts—a knowledge of literature and history, science and the arts—all of them will prove to be a vast reservoir to draw upon, as valuable as the technical skills that an art school would provide. Moreover, the technical skills are sometimes better self-taught. And they're learned almost osmotically (they're in the air; they can't help

permeating us). The Australian critic Clive James has this to say about self-education: "The technical expertise artists really do need they will be driven to acquire by the demands of their talent."

Suppose Seth goes to college, decides to become an illustrator, and—*bingo!*—gets an assignment to illustrate an article on the savings and loan scandal. Seth might see this as an instance of overweening greed, or hubris (after all, hypothetically speaking, he had just read *The Iliad* in English 101 and learned about hubris). He might then think of Midas, about to give his only son a golden embrace; or Icarus, attaching waxen wings in preparation for his sunbound flight. Granted, these may not be the best solutions for the illustration—and if they are used, may escape our mostly uneducated public (not so much uneducated, on second thought, as *badly* educated; educated by the media that pervades so much of our lives). But the point is that Seth's mind will be roaming far and wide because his references will be broad and deep. An enlarged frame of reference gives breadth to an image. It communicates a shared set of values to an audience, and then passes those values on to future generations—passing on a necessary tradition of culture.

Seth doesn't have to learn about art by going to art school. He can learn it by listening to Mozart (or Duke Ellington or Ella Fitzgerald). He can learn by hearing the way Mozart dramatizes his music and keeps the listener's attention through contrasts: long phrases alternating with short, the orchestral with the solo instrument, the major with the minor, and so forth. Any and every art form can instruct and stimulate the others. Robert Schumann, speaking of the Romantic novelist Jean Paul Richter, once wrote, "I learned more counterpoint from Jean Paul than from my music teacher." And maybe Richter, the novelist, learned a thing or two from Schumann, the musician.

If Seth does take my advice and goes to college, he would be wise to carefully check out the school's studio courses before taking them. Here's why. They're taught by MBAs, the sine qua non for most college teaching positions. But how many artists would *bother* to get a higher degree? They're too hot and eager to start making art. Of course, some of the best teachers are the worst artists (and vice versa), just as writers manqué can be wonderful lovers and expositors of literature. George Bernard Shaw is not necessarily fair when he writes that "He who can, does. He who

cannot, teaches." But I've found that some who "cannot," *can* teach. And very well. The point is that Seth should carefully check out the qualifications of teachers in the studio arts. They can either be unvisual—really!—or competitive—really!—or too narrowly focused on what art is all about. In short, they can be dangerous to emotionally vulnerable novitiates.

Now for the reverse side of that coin.

Did Hemingway need a B.A. to write *The Sun Also Rises*? Did Mozart attend a Salzburg conservatory, or Leo Tolstoy a University of Moscow? Did Herman Melville attend Harvard before writing *Moby Dick* ("a whaleship was my Yale and Harvard," he wrote), or Joseph Conrad go to Oxford before writing the *Heart of Darkness*? No. Conrad's university was his years under the sail. His background as sailor, smuggler, gun runner, and adventurer—these, and these alone, gave him the material, the stimulus, and the inspiration to create his extraordinary stories. In some cases college can even be a hindrance. It took E. L. Doctorow ten years after graduating Kenyon College to write English rather than academese. And it took several years after that to leave the secure life of an editor for the insecure one of a novelist. College can be the breeding ground for all sort of habits, and habits are

the death of art. It can teach you what has been done, but often at the expense of what *can* be done.

The academic life can also endanger artists who become teachers. Here's what a report by Harvard's Committee on the Visual Arts has to say:

> *In too many cases, unfortunately, the artist-teacher gradually develops into something else: the teacher who was formerly an artist. Too often the initial basis of appointment was fallacious. In the desire to find an artist who would get along with art historians, the department acquired a colleague who got along well enough but turned out to be neither much of an artist nor much of a teacher. . . . Over a long period of time, the danger is that the artist will produce less and less art while still preserving the attitude that his teaching is of secondary importance to it.*

This is a bad situation for the teacher, and a bad situation for the student. Nobody wins.

"Ignorance can be bliss," Arthur Koestler states, referring to the dangers of academism. He cites the cases of Faraday, who invented the electric motor; and Thomas A. Edison, who seems to have invented

almost everything else. (Edison, incidentally, was considered feebleminded by his parents. "When will he ever stop asking those damn fool questions?" they lamented.) "To Faraday, his ignorance of mathematics was an asset; Edison benefited from his shocking ignorance of science," Koestler concludes. Neither realized that they were doing what their peers had considered impossible.

History is replete with examples of the self-taught master. When Gian Carlo Menotti was approached to do a film version of his superb opera *The Medium*, he spoke to that polymath creator Jean Cocteau. "How do I make a film?" he asked.

"By making it," Cocteau replied.

Often the most supremely gifted creators will doubt their own abilities. George Gershwin once asked Maurice Ravel if he would accept him as a pupil. Ravel refused. "I want you to be a first-rate Gershwin, not a second-rate Ravel." (The tables were turned when Ravel learned how much Gershwin earned from his music. "Teach me how to do that," Ravel said.)

There may be art schools that offer adjunct courses in the liberal arts. These may be the schools Seth should look into.

So there you are. Take the coin, and let Seth do the flipping. His toss may be as good as mine.

All best wishes,
Bob

(Now why did I write "Bob"? My hand wrote it automatically, and maybe purposefully, as by now we ought to be on a first-name basis. But I should mention that my given name is Oscar, not Robert. So why "Bob" And why "R. O."?

I can't remember why or when I chose initials as my pen name, reversing my first and middle names, but I suppose I thought that initials lent an aura to a name, a mystery, a hook to catch a viewer's attention. Is E. M. Forster an Edward, an Edgar, an Edmund? [he was called Morgan by his friends]. Is T. S. Eliot a Theodore, a Thomas, a Timothy? [he was called Tom by his intimates, but he signed his notes Eliot. I know. Lucky me, I have one of his notes—something that dropped out of a Hogarth Press pamphlet I once bought].

So there you are. I'm R. O. to strangers, Bob to my friends. And since I signed this letter "Bob," welcome friend!)

July 1, 1984

Dear James,

I'm returning your cartoon with a gold star. Only one? I could plaster it with dozens, I like your drawing so much. But I don't dare do anything to distract from your drawing.

What a concept! Isaac Newton reclining beneath that legendary tree, only to have the apple fall, unseen, on the other side. Brilliant!

Your drawing so perfectly comments on the arbitrariness of life, how one event, so small in itself, can be world-altering. If Charles Darwin had not voyaged on the *Beagle* and not stopped at the Galápagos, could he have conceived his theory of evolution? If Alexander Fleming's window had not been left open one night, and if a passing spore had not happened to land on a culture of bacteria and killed them, could he have gone on to discover penicillin? In fact, it was pure chance that Fleming even enrolled in the hospital where his research was conducted. Saint Mary's Hospital had a water polo team that Fleming wanted

to join. Later he changed his branch of research to bacteriology because Saint Mary's had an opening on its rifle team and Fleming was a crack rifleman. Talk of happenstance!

These and other instances of fateful accidents—the discoveries of photography, X-rays, and pasteurization—they come to mind when I look at your wonderful drawing. History is rife with instances of apples just happening to fall on a tree's "right" side. Your concept is so brilliant, so funny and insightful in equal measure. But I am tempted to clip an edge off the star I put on your cartoon. The drawing is not quite worthy of your concept. Your Newton is perfect. Your apple as well—even having a single leaf on the right side of the apple to emphasize that something is happening only on one side (the wrong side!) of the tree. And how nice that the leaf is bending with the direction of the fall. I'll bet that you acted out the situation while drawing it (my wife says that when I draw, I often laugh, grimace, or groan as I experience the emotion I'm trying to express). But the leaves of the tree could have been a little fuller, the foliage a little higher. The tree looks shorn. But this is a quibble, and now that I think about it, a silly one, so forget what I just wrote.

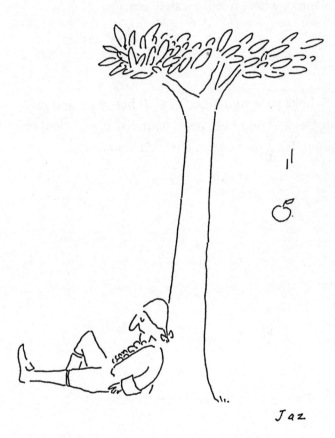

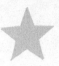

Brilliant, James!

So here it is, your drawing returned—and with a *full* star. I don't have to keep the drawing. It's fixed in my mind, where it will lovingly remain.

Best wishes,
Bob

P.S. I like your signature, "Jaz." It has spark and playfulness, and certainly beats your full name, Wetherington. It's a nice name, but what a mouthful!

July 8, 1984

Dear James,

So Emily seems to be more wrapped up in her work than in you. *Tant pis!* Is that so terrible? The fact that she wants to pursue a career in fashion just means that she is concerned with things visual, and that is all to the good. If she wasn't visual—if she didn't share your sensibilities—how would you feel if she dressed like a sixties flower child, or wore colors and patterns and styles with no regard to their appearance—or to your sensibilities. Consider yourself fortunate. She shares your values.

The problem I foresee is that she has chosen a field that concerns itself neither with beauty nor even with practicality. Novelty alone counts. The more outré the statement, the bigger the splash. Worse yet is the bottom-line mentality of manufacturers. When she graduates from FIT, she'll probably find that the field is both overcrowded and indifferent to anything but the marketplace. (Not that most owners have any understanding of the marketplace. They have

eyes—to cite that atrophied organ!—merely for what the competition is doing. Their eyesight is strictly peripheral.)

Your letter complains that when Emily sleeps at your place, she sometimes snores. Is that her worst fault? James, you're lucky. What you really seem to be saying is that Emily is not perfect. I have news for you. Nobody is. That's not the way we're made, and I mean that literally. Did you know that the human face is not symmetrical? One side is slightly (but imperceptibly) different from the other. That may be God's way—or nature's, as you wish—to tell us something. Carpet weavers in the Near East know that. Their carpets are always slightly asymmetrical. A color or a pattern is never repeated exactly. That puts the human signature to their work. It's not any different from the signature that you find in a drawing when a line is crooked or broken, or a blob of paint forms, but falling in just the right place. The "flaws" are what connects us to the work—that say "a person has made this."

About perfection, Thomas Mann has this to say in his novel *The Magic Mountain* (and, James, this is a book you must read!). His protagonist, Hans Castorp, is lost in a sudden late-winter snowstorm (a metaphor

for the sudden storm that was to convulse Europe in 1914?). He observes the flakes swirling around him:

Each of them was absolutely symmetrical, icily regular in form. They were too regular, as substance adapted to life never was to this degree—the living principle shuddered at this perfect precision, found it deathly, the very marrow of death—Hans Castorp felt he understood now the reason why the builders of antiquity purposely and secretly introduced minute variations from absolute symmetry in their columnar structures.

Now back to Emily. I hope she succeeds in her work (and stops snoring). But whether or not she succeeds in both or either, count yourself fortunate that she can act as a sounding board for your work. She can tell you if it reads, and if it looks good. That's valuable. At times it's even more than valuable; it's essential.

I recently read that E. M. Forster considered abandoning what many consider his masterpiece, *A Passage to India*. He showed the manuscript to Leonard Woolf. "I thought the book bad," Forster later wrote, "and probably would not have completed it without

the encouragement of Leonard Woolf." Now what if he had not shown it to Woolf? Or what if Max Brod had obeyed Kafka's deathbed injunction to burn all his unpublished papers? I can't help wondering how many works of art have been saved, and how many were lost, due to advice and support, given or withheld.

Art is a lonely business. To be judge and jury of one's own work is difficult and exhausting. Another pair of eyes should be welcomed.

> All the best,
> R. O. Blechman
> (Oops! So let the
> full name remain.)

July 22, 1984

Dear James,

I'm glad you liked my op-ed drawing. It wasn't easy to do, and don't ask me why. The subject certainly was an inviting one, "Broken New Year's Resolutions," but for some reason I sweated this job. Fortunately I was given a lot of time to come up with the illustration—more time than I'm usually given. As you know, the deadlines are often very tight—24-hour turnarounds—but on this assignment I had two full days to send in a sketch, and another day for the finish (not that I bother with sketches; I like to go directly to the finish). It's the details that make all the difference between a job reading clearly or not, and one looking attractive or not. "God is in the details," Mies van der Rohe said, and if you question that, just look at his Seagrams Building, where a generic glass tower has proportions that are exquisitely correct. It is the details—the classically proportioned windows, for example—that make all the difference between elegance and banality.

That said, one must guard against losing the vitality and freshness of the initial sketch.

I won't bore you, or embarrass myself, by showing you all the false starts I made before I got to the finish of my drawing. I sketched a dozen or more ideas, one of which I rather impulsively faxed to the art director soon after I received the assignment. (It's always a good idea to sleep over something before sending it. And this holds as true for letters as it does for drawings. The next day's light can be illuminating.) As it happened, the editor *did* accept the sketch. But I could tell that the acceptance didn't come with any enthusiasm—something I might, or maybe should, have predicted, since my wife, who saw the drawing before it was sent, didn't much care for it, either.

Anyway, I knew there had to be a better solution (my friend Bob Gill says there always is), so I just kept on drawing and doodling, taking my line "on a walk," as Paul Klee put it, with no clear direction in mind, just letting free association do its work. Steinberg had this to say about the value of free-associating: "In making a drawing or even starting a phrase—let's talk about starting a phrase—I have a very vague idea of what I'm going to say. During the time I say it, the

conclusion and the main idea, I hope, will come in."
With Steinberg, it usually does.

Doodling taps the unconscious, that vast creative reservoir an artist dips into for ideas. A line is cast, it floats . . . now here . . . now there . . . aimlessly drifting in deep and hidden currents, and then, with a start, a prize emerges from the dark, glistening.

I happen to still have the drawings that led up to the finish. You might be interested in seeing them. I'll send some of them along with this letter.

All best wishes to you,
Bob

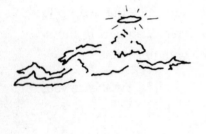
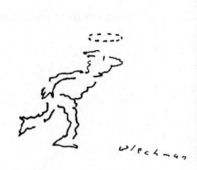

This was the first drawing I did. I sent it to the Times and it was accepted. But I knew there was a better solution.

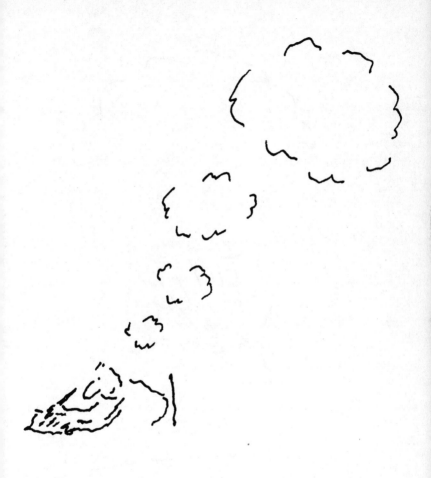

I tried this.

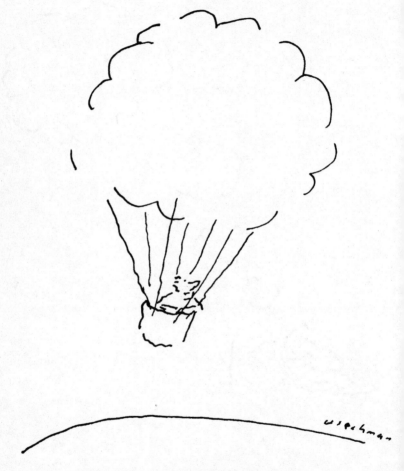

Then I turned the thought balloon into a bubble.
But the balloon no longer read as a thought bubble.

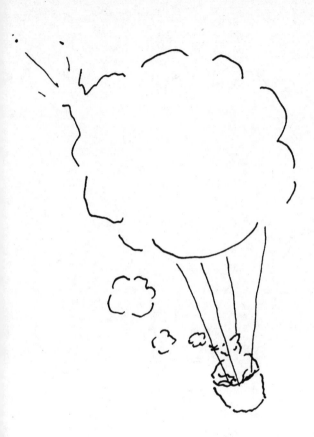

Vlechman

*Now it does. I punctured the balloon/bubble to convey
the notion of a broken resolution.*

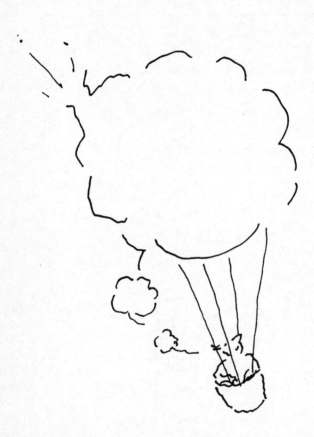

I added tails to the thought bubbles to make them read more clearly.
This was the drawing that was published.

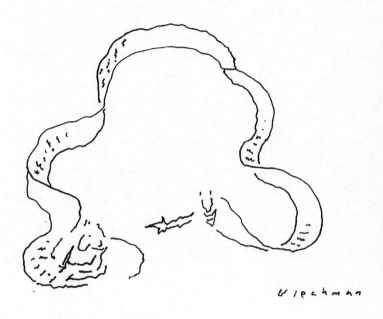

I also sent them this drawing, just as a fallback solution.

I did this one also, but didn't send it out.

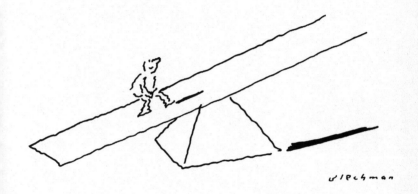

Here's another drawing (also not sent out).

August 4, 1984

Dear James,

This probably isn't worth a letter, it seems so unimportant now, but at the time it affected me deeply.

I was in one of those Marlboro bookstores last week. You know the places. Graveyards for remaindered books. Places where authors slap their brows at the sight of *their* heavily discounted books, books only a year in print—a year in print but years in the making, and think, *Okay, that's it. Who needs this? Who needs to spend days and nights and weekends and holidays scribbling away with hardly a break, only to end up with a bad review—a stupid! a really stupid!—review in* The New York Times, *with your best friend, an editor no less, telling you, "Look, a bad review is better than none, right?" Wrong. Sure, he can talk. It's not his book. It's not his book that ends up with the label "Reduced to 59 cents," like a toe tag in a morgue.*

I'm reminded of what Georges Bizet said about opera, and it could have been said about so many

other creative fields. "What a wonderful art form! What a rotten profession!"

So, back to the Marlboro bookstore. There I was, browsing at tables piled high with books, when I saw an interesting item. A book written by Bella Chagall (Chagall's wife? daughter?). It was called *Burning Lights,* with "Thirty-six Drawings by Marc Chagall." How could I resist that book? How could *any* illustrator resist it? What a textbook—what a treasure trove—of Chagall's drawings! What a lesson on how a pen line can be so incredibly and eloquently varied—thick, thin, dotted, stippled, crosshatched! But that jacket! A wispy wash drawing of the author, so unlike the magisterial work of the master. Undoubtedly the publisher had commissioned another artist to do the jacket, perhaps because he thought it would be more "realistic" than the heavily stylized work of Chagall, and therefore more salable. Forget that the book was about Chagall's wife, and featured her husband's work! The jacket, so the publisher must have thought, had to appeal to the public.

I hesitated to get the book—that jacket!—but then I thought, *Look, I can remove it, just toss it out. Like a good wine with a rotten label. I can just pour the wine in a decanter, then throw the bottle away.*

I bought the book.

Now here comes the crazy part. Back home I was curious to see whether the jacket artist was given a credit line, or whether it was done by that standby of so many publishers, Anonymous. I turned to the flyleaf, and there, at the bottom of the page, was the credit: "The jacket shows a portrait of Bella Chagall by Marc Chagall."

Marc Chagall?! How could he have done it? Did he feel that it was required, either to satisfy his wife, or satisfy the publisher? Or—and this occurred to me— maybe it was simply that an artist's style is not necessarily natural, not something inevitable, but rather something of an artifice. A mystery. The conclusion I draw from all of this is that sometimes great artists make great mistakes. The book cover is one for the Museum of Failed Art. But not for my bookshelf.

Well, James, I did say that this probably isn't worth a letter, but since I've written it, I'm not going to throw it out. Like a bad jacket. Or a bad wine label. I'll just get back to my work and consign this letter to the Museum of Failed Correspondence.

All the best to you,
Bob

August 20, 1984

Dear James,

I received your mailer, and like it a lot. Good drawing, good idea. I'm glad you took the initiative to promote yourself. It's essential that you keep your name out there. If not through your published work, which is the ideal way, then through your mailers. You'll find that when you send out a few hundred, a few dozen will be kept; then a few calls will come in; and then maybe, just maybe, a job will be landed. Or not. But the important thing is not to be Miniver Cheevy—remember him?—the man in the Edwin Arlington Robinson poem, that "child of scorn . . . [who] wept that he was ever born . . . and thought, and thought, and thought . . ." And did nothing. And from nothing comes nothing.

As a child, I was intrigued by an animal in one of my treasured Doctor Doolittle books. It was a pushmi-pullyu ("push me–pull you"). On both sides of its body was a head. One head kept saying "Push!" The other kept saying "Pull!" So the animal just stood

there, absolutely motionless, its heads in perpetual conflict. I suppose there's a little pushmi-pullyu in all of us.

Now back to your mailer. I agree with you, it's a real shame that the stock you used was too thin. There's nothing like heavyweight paper to breathe distinction and elegance to a mailer. The difference between a heavy and a light paper is like the difference between engraving and thermography. Thermography is really fake engraving (although thermography has its uses, but *never* for business cards). It's also like the difference between letterpress and offset lithography. Letterpress "bites" into the paper and gives it a wonderfully tactile presence, while offset lies flat and dull on the paper.

Your problem was that you made an assumption, that your printer would use a suitable stock for your mailer. Assumptions are dangerous.

My printer has a sign, ASSUME NOTHING, next to one of an Indian shooting an arrow, below which is the legend WE AIM TO PLEASE. That sign misses its aim for me, but the first sign, ASSUME NOTHING is right on target. When assumptions are made, disasters sometimes follow.

A case in point. I assumed that my *L'Histoire* of

58 minutes (the required length for an hour-long television program) would clock in at 58 minutes. Wrong. My editor came to me last week to say that it was a few minutes short of the required length. *A few minutes short . . . ?!* What was I going to do? I had to deliver the film in two weeks, and animation is devilishly expensive and time-consuming. Well, what we decided to do was shoot a live action coda, something about Stravinsky's work habits, relating them to the way we create our animation (not that we were sure of the connection, but it was something we felt could be justified). So I left the drawing board for the writing desk and turned out a script of sorts—a scenario that is being shot as I write this. And I must say that it's looking good. Remember that diagram I sent you a few letters back—the one with the 9 dots that had to be connected? Well, thinking outside the assumed frame of reference seemed to work. The live action coda is turning out well. It matches nicely the live action that begins the film. It seems to make a good—a natural—bookend.

So much can go wrong when assumptions are made. A common and reasonable-enough assumption is that when a drawing is handed in, it will be reproduced as it was drawn. Not so. Some art

directors will enlarge it, others will reduce it, and in some cases, when the drawings are sequential, they will mix and match sizes—some blown up, others reduced—making for some kind of Dada eye chart. Not that scrambling sizes is necessarily bad, but it *usually* is—and in any event, it's done without the illustrators' okay.

What I try to do—*try* to do—although I don't always succeed, is see the layout before it leaves the art director's desk for the printer. It's not always possible. Some art directors will appreciate your concern. Others will resent it. But the result is always worth the effort.

I once did a campaign for *Look* magazine—you know the publication, one that's intended more for the eye than the mind. The magazine's very name, *Look*, says it all. The campaign positioned itself as something investigative and intellectual—a ridiculous stretch, and a transparent one—probably to distinguish itself from its archrival *Life*. The campaign was made sillier by its use of a totally inappropriate typeface, Cooper Black, the very antithesis of sophistication. Every letterform of Cooper bulges with abs. And when the letters are tightly spaced, as they were for the headlines, Cooper's machismo is exaggerated.

One of the ads bore the headline, "A Word to the Whys." Working with that wretched pun, I pictured an anthropomorphic question mark examining its navel (maybe not the most brilliant illustration, but the best I could come up with given the headline). So that was my drawing. But that's not how it was (nearly) published. The platemaker thought that the navel was a speck of dirt and removed it— removing, as well, the very point of my illustration. Fortunately an alert checker at *Look* caught the mistake and corrected it in time. Here, I'll show you the drawing.

That's one mistake that was caught in time. But here's an example of one that wasn't. I was at my printer to check out a promotional mailer I had designed. I saw the proof, made a color correction, saw a second proof, okayed it, then left.

What I hadn't counted on was that after I had left, the pressman might take a coffee break—or maybe go out for a smoke—and not check the flow of ink during his absence. And that's what happened. When the pressman returned, the dense color I had approved at 8:00 A.M. had become an anemic shadow of itself by 8:20. That Indian had forgotten to *keep* his eye on the target.

How to tell a What from a Why

There are two basic types of communications media. The kind that reports *what*...and the kind that explains *why*.

The What media are far more numerous.

Radio and TV, for example, tell you what happened earlier in the day. The morning paper tells what happened yesterday. News magazines are full of what happened a week ago. And there are specialized magazines to let you know what to do with leftovers, what countries to visit, even what to tell your teen-age daughter.

So much for the Whats. They do a fine job, but they leave a great deal unsaid—like *why* things happen. And in today's world, the Why factor can be critical.

To learn the Whys, 32 million adult Americans turn to LOOK. For LOOK is a Why magazine.

Issue after issue, LOOK—virtually alone among major media—digs deeply into key problems of our day. Why are we involved in Southeast Asia? Why are America's young people disenchanted? Why—after centuries of quiet resignation—are Negroes rebelling?

For LOOK is a different kind of magazine. It selects the thoughtful reader. It is read in a questing frame of mind.

Can you think of a better place to tell people *why* they should buy your product?

LOOK. You'll see why.

Newsweek November 25, 1968

The job was ruined—well, hurt, not ruined—but at least I had learned a lesson. And the pressman did, too. And the owner: He had to run the job again.

Moral: "Assume Nothing." An illustration isn't finished until it's in print. A film isn't finished until it's in the can. These are hard lessons to learn, and, like most lessons in life, necessary to relearn . . . and relearn . . . and relearn. . . .

All best wishes,
Bob

September 12, 1984

Dear James,

You ask a good question. Why is illustration considered minor, and painting, major? Why is a higher value placed on gallery art than on so-called commercial art?

This distinction would have seemed pointless, if not absurd, to a Renaissance artist. Botticelli's contemporaries admired his illustrations no less than his canvases—and no wonder. His drawings for the *Divine Comedy* were . . . well, divine. To an Italian artist of the sixteenth century, the scale and use of his work were irrelevant. Only the visual quality mattered. A medal, a mural, a clock face, a mosaic, all were undertaken and prized. Cellini crafted bronze statues and diamond rings, ecclesiastical robes and salt cellars; then he'd pick up a hammer and pound away at a life-size statue of Christ. Everything was grist for his ever-churning creative mill. Nothing was too small, nothing too large, for his restless energy. And he was typical of his peers.

But one doesn't have to look back that far. Picasso dipped his hands in clay as readily as his brush in

paint. The scale, the use, the context—museum wall or dining table—these mattered little to Picasso. It was art, period. Are Rockwell Kent and Ben Shahn painters, or illustrators? Both, of course. Neither category defined or confined them. They were simply artists, and artists create art in any and every scale or mode.

Olivier Bernier, in his lovely book *Pleasure and Privilege*, a study of late 18th-century France, Naples, and America, writes about the contemporary disjunction between minor and major art forms.

> *The "decorative arts," a phrase so often spoken with contempt (the worst thing you can say today about a painting is that it's decorative), were then considered, rightly to be art, period. . . . A whole society of rich, idle, but immensely discriminating patrons cared passionately about things like dinner plates and armchairs. . . . [In] those twenty years before the Revolution the latest set of Jacob chairs, the latest Reisener chair, the latest salon, with its boiseries and mirrors, curtains and vases, mantelpiece and furniture, represented not just a trend, not just a pleasant look, but an artistic triumph. In a very real sense the great cabinet makers were just as truly sculptors as a man like Houdon.*

How damaging, how destructive, this cultural gap between the art forms! It drove a supremely gifted Maxfield Parrish from the sublime illustrations of his books to the kitschenware of his paintings. It occasionally turns an André François away from his natural bent as a superb illustrator to the sometimes pretentious one of a gallery artist.

I once visited the photographer Lartigue in his Paris home. The walls of his living room were covered—floor to ceiling—with his oil paintings. Lartigue's photographs, however, were nowhere in sight. When I asked to see them, he returned with an armful of family photo albums, the photographs themselves mounted indifferently. Apparently what mattered to him was his "art." Photographs did not fall within that hallowed category.

Writers—many of them—are aware of this danger. Graham Greene invented what he considered a subcategory of his novels. "Entertainments," he called them, hoping that by this lighthearted term he would avoid the heavy-breathing scrutiny of the literary world. Virginia Woolf welcomed the opportunity to escape what she considered her "important" writing by crafting essays and reviews, and fashioning such whimsies—as she no doubt considered them—as

Flush ("too slight," she confided in her diary), and *Orlando* ("that joke"). Begun as a diversion from writing a novel that weighed too heavily on her, *Orlando* ended up as a work that Nigel Nicholson described as "the most charming love letter in literature." These "entertainments," these "jokes," often turn out to be works of the greatest and most lasting value.

The unique advantage that an illustrator has over a painter is that the illustrator has the gift of boundaries. A text limits an illustrator's options, and this can be liberating, not restricting. "[Nothing] is harder to bear than complete freedom," remarked the art critic E. H. Gombrich.

So, James, forget the traditional and entrapping categories of major and minor. Good art is major. Bad art is minor. Good and Bad. Those are the categories—the only ones—that matter.

<div style="text-align:center">

As ever,
Bob

</div>

P.S. You won't believe this, but a friend of mine in England sent me an enamel pin reading "Minor Bob." I wear it as a badge of honor.

September 18, 1984

Dear James,

So you made the break! Good. It probably was the right decision, especially now that you're illustrating the Letters column for *Fortune*. There's not much money in that—what is it? A few hundred a month?—but at least it's steady, and it's seen, and that's important. Of course, your work is as steady as your editor's tenure at *Fortune*, and that isn't necessarily long term. I should know.

I once illustrated a Letters column for *House Beautiful* (and coincidentally, for *Fortune*, for several years, back in the fifties). After several years of illustrating the *House Beautiful* Letters to the Editor column, the editor retired (or was retired—I never learned). I was invited to his farewell party. Little did I suspect that all those bubbling flutes of Moët et Chandon were raised not only for the editor but for his illustrator as well. I learned fast. The next issue of *House Beautiful* featured a new Letters to the Editor column—and illustrations by the new artist. O tempora! O mores! I

wish you a longer life with *Fortune* than I had with
my magazine.

Now that your boat has pulled up its anchor and left its
longtime harbor, I wish you a long and prosperous voy-
age—one to the uncharted seas and far from the crowded
ports of call (there's a French poem about this, but I can't
for the life of me find it; if and when I do, it's yours).

All best wishes,
Bob

P.S. Well, I didn't find the poem, but while looking
for it in a secondhand bookstore, I came across an
extraordinary drawing by Steinberg. It's an object les-
son in how feeling translates into form.

It portrays the moment when a man-made light
challenged the sun and threatened (and threatens)
to plunge our planet into permanent darkness. The
scene is Hiroshima on that hot August day of 1945,
when Little Boy was dropped on a city of several
hundred thousand, killing 80,000 civilians instantly,
eventually 60,000 more.

Steinberg, with all the obsessive attention to detail
of a folk artist, portrays the event as few artists before
or after him. There is no conceptual trickery in his
drawing, no sham posturing, no mushrooms shaped

like skulls. He neither condenses nor cerebralizes. He notes it all. What John Hersey wrote as a book, Steinberg packs into a single drawing. All the victims are given their due. Every house, it seems, every building, every tree, every person, every car, train, track, boat, every fragment of what once were people and things, everything is flung into the blazing sky with the obsessive, frenzied strokes of a van Gogh. Dwarfed by the explosion, virtually hidden in the immense arc of the blast, is a toy-sized dot: the life-giving sun. We are not allowed to escape the scene by immediately apprehending it. No, we are compelled to identify each of the tantalizingly vague objects—those, that is, not made unrecognizable by the viscous black swirls of the explosion. The scene does not invite study; it commands it.

Steinberg wants us to feel what he himself felt: the inescapable horror of that moment. As Picasso's *Guernica* personified the tragic thirties, Steinberg's "Hiroshima" has given us the ultimate expression of our era.

The passion he pours into this drawing, the craft he gives it, the care, should be an inspiration and a yardstick to us all.

Warm regards,
Bob

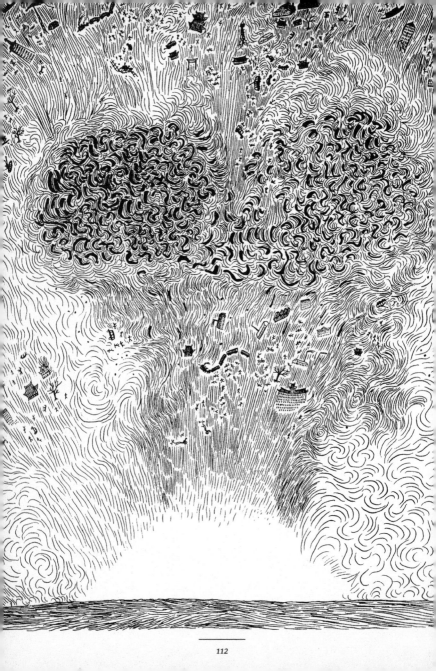

October 1, 1984

Dear James,

I'm going to slap your hand—but not your drawing one—for turning down that job. Sure it's silly. An ad for vegetarian meatballs?? Spare me! But that job should be welcomed. I often do my best work when I work for the worst clients. It's then that I feel free to do what I want, period. And if he or she or they don't like it, at least I did what I like, and I can live with myself (and take a stroll to the bank with my cancellation fee).

Here's what Ben Shahn had to say about this kind of work. ". . . never be afraid to undertake any kind of art at all, however exalted or however common, but do it with distinction."

"Do it with distinction." There's the justification for painting a mural, mopping a floor, or plugging meatballs.

If the job is accepted—that ad for meatballs or whatever—then your reputation will not suffer from what will be viewed simply as an aberration. Seymour

Chwast works for *Forbes* magazine, and for God knows how many progressive groups and causes, but nobody faults him for wielding a fickle pen. He has to earn a living. People realize that. Of course, if he worked for the American Lung Society and then went on to work for Herbert Tareyton Cigarettes, that would be something else. There are limits to the public's tolerance, and to one's own need to earn a living. (As if one takes on work to "earn a living." We take on work to make money—the more, the better, isn't that so?)

A corollary of pleasing oneself is that you usually please others. The differences between us and the public are fewer than the similarities. "I contain multitudes," Walt Whitman proclaimed. That's why any artist worth his salt works for an audience of one—himself—the only audience he truly knows. In doing so, only then will he reach the "multitudes."

I'm reminded of an exhibition I recently attended of Édouard Manet still lifes. At first I was reluctant to go. Who wants to see apples and oranges from the painter of *Le Déjeuner sur l'herbe? The Execution of Emperor Maximilian?* The naked *Olympia?* That was the Manet I knew and loved, and that's all I wanted to see of Manet, thank you. But as a courtesy to my friend I went. To my delight, and not a

little amazement, I didn't see apples and oranges, but great paintings, pure and simple. Manet, relieved of the obligation to choose and render a subject from the infinity of possibilities, chose to limit himself to the small world of still lifes, and thus was free to explore the possibilities of the oil medium. And this he did with abandon, slathering paint, thick and juicy, on the canvas. Like his predecessor and mentor, Velasquez, like the late paintings of Frans Hals, or the Rembrandt painting of a flayed ox, Manet exulted in pushing the unique qualities of pigment and brushwork to the limit.

You can do the same with—yes!—meatballs. Explore to the max the possibilities of what you have to work with—humor, technique, and concept. So call Mr. Meatballs, tell him that you changed your mind, or that your schedule has opened up, and that you're now free to take on the job, and then . . . have fun! So will everybody else. Mr. Meatballs, too.

All best wishes,
Bob

October 14, 1984

Dear James,

Yesterday I had lunch with an old friend of mine, somebody I see too rarely. That's the way it is here in the city. When I'm in London or Paris, I notice that a workday ends with artists meeting at a bar or coffeehouse to talk shop. Not here. In New York, at the end of a day, we climb into buses and subways and talk shop to ourselves. Not a very collegial or productive scenario, and no blessing to spouses or partners who have to hear all about telephone calls not returned or drawings unfairly rejected.

The surrealist Max Ernst came to the United States shortly before the Second World War. He was married to Peggy Guggenheim, that inveterate socializer whose weekly parties in Manhattan were the closest thing to a Paris salon. Despite this, Ernst later complained about the isolation he encountered in New York. ["It] had no communal life, no cafes, no communication."

Anyway, about this lunch. My old friend Alvin is

a real lover of aphorisms and good food. Somewhere between the arugula and the grilled salmon, Alvin said something worth pondering. Speaking of success, he said it comes from persistency and consistency. (This happens to be advice that he doesn't necessarily follow himself. I never know when I'm going to lunch with a plump Alvin or a trim one. Not very "consistent" behavior. But at least he regularly diets, so he's "persistent.") I suspect that he gave me this advice because he was uneasy about my frequent forays into graphic design and animation—distractions, he may have felt, which hurt my image, and my career, as an illustrator.

Consistency and persistency certainly mark aspects of Andy Warhol's career. Both Alvin and I knew him back in the mid-fifties when he was starting out. I knew him because I was both his colleague and a Murray Hill neighbor (and a good-looking young man, which didn't harm our relationship at all; what *did* harm it was his handshake, which was like clasping a damp rag.) Alvin knew him because he was head of a small advertising agency that commissioned his illustrations. Alvin, incidentally, claims that he gave him some valuable advice (as I mentioned before, Alvin just loved giving advice). "Get a camera," he told Andy, "and use it for your work."

We both were on his mailing list and regularly received his hand-colored illustrations. I chucked mine. Too cutesy-pie, all those pink angels and pastel butterflies; too derivative, all those Ben Shahn burred lines. Alvin had the prescience to keep them all. Who knew that the guy would become famous? Alvin, I guess.

Warhol had the sense to establish himself with a regular, identifiable style—"consistency"—and then to market it with "persistency." He then moved into new areas—areas that were sure to be conversation pieces. Films like *Sleep* (which was bound to induce it—and bound to attract loads of cocktail chatter and publicity), and photo murals of Marilyn Monroe (with Alvin's camera?) and Campbell's soup cans.

Warhol had the ability to shed styles like last year's fashion, always one ahead of the public's expectations. That was fine for him, but for an illustrator, a danger. Take the case of the great Paul Davis. A master hyper-realist (and with an identifiable look all his own), he went from highly acclaimed posters for the Joseph Papp Public Theater to a faux naïve, sketchy look for such campaigns as radio station WNCN. You can't pass a bus in New York these days without seeing them. An art director might hesitate to

commission art from him. Which Paul Davis would he be getting?

Unless you're a Picasso, and can switch with bravura and grace from 19th-century realism to a Blue Period to Cubism to an Ingres Neo-Classicism to God-knows-what-next, my advice to you (as I echo Alvin) is to stay with what you know best, and make it better by making it grow integrally. That's achievement enough.

All best wishes,
Bob

November 3, 1984

Dear James,

I'm at my country home for the holidays, virtually snowbound after a heavy fall of thick white flakes throughout the night. Fortunately a plow cleared our lane so that I could drive the six miles (aaargh!) to get a *Times* with your drawing in it. It's only luck that my Volvo—peculiarly unequipped for snow (and this is a *Swedish* car?!)—didn't end up in a ditch. Our highway department prides itself on its deep ditches. Fine as tank traps, but who has to worry about an invasion from Massachusetts?

Come to think of it, we actually *were* invaded by Massachusetts. Back in the 18th century, a band of their militiamen occupied our town of Ancram (we're only a few miles from Massachusetts). They stayed for several days and seized several townspeople. The border dispute was soon settled, I suppose because our town wasn't worth spilling blood over. Less than a decade later we found a joint enemy in Great Britain, and ever since then relations between our states have been neighborly.

But a more serious invasion occurred a century later. This time, not by a few dozen militiamen but by 10,000 rough-and-tumble civilians.

For most of the nineteenth century, boxing was illegal in America. And no wonder. Bouts were bloody, fought bare-fisted, often with fists coated with a liquid that hardened like cement. The events frequently lasted several dozen rounds. They were often staged on barges, outside territorial limits, and fairly inaccessible to the authorities. One such fight occurred in Boston Corners, a few miles from my country home.

The hamlet of Boston Corners is perched on a high rise of the Berkshire foothills, midway between New York and Massachusetts. Long a refuge for drifters, roustabouts, and fugitives from the law, Boston Corners was as remote as an ocean barge: an ideal spot for an illegal boxing match. And in 1853 that's what happened. "Yankee" Sullivan and John Morrissey fought a bout that that lasted 55 minutes and 37 blood-splattered rounds. The 10,000 fans got their money's worth.

But their adrenaline was overflowing, so the mob took over the town. Around dinnertime, reported one contemporary, the fans slaughtered "every chicken, pig, and lamb in sight." Afterwards they bedded down

in "every barn, front porch, and back field." The next morning they "persuaded" the station agent to flag down a freight train bound for New York City.

That year, Massachusetts happily conceded the place to New York State.

Life is calmer now. No boxing matches, no boundary disputes. The only flurries come from clouds, not crowds; the only gunshots from hunters, not militiamen. So in the peace and quiet of my studio, I can sit by my wood-burning stove and enjoy your cartoon.

Before commenting on it, I couldn't help noticing that your illustration was for a well-known political commentator. That speaks well for you. Suares is pretty choosy when it comes to selecting his artists for celebrity writers. (But I just realized. Suares is no longer art director. It's Jerelle Kraus. That job is so pressured—art, twice a day, every day of the week. And articles get bounced and changed constantly, just as art gets rejected, often unpredictably, by the editors. So the pressure is enormous, and the turnover of art directors is constant. I know this firsthand. My son Nicholas was an art director for two harrowing years. Whenever an artist didn't come through, or whenever an artist's work was rejected by one of his editors, Nicholas had to replace it with one of his own

drawings—signed pseudononymously as Art Hughes or Johnny Sweetwater or by his everyday pen name, Knickerbocker. He had a whole battery of pseud-onyms.)

So, finally, back to your drawing. It so nicely expresses the situation of the writer—and, by extension, of anybody in the creative arts. Behind the finished text, seemingly arrived at with ease (the flow of the words appears so conversational, so improvised), lies the wastebasket, full to overflowing with drafts and redrafts. You convey this nicely. And so artfully. I notice that the rear of your basket does not repeat the pattern. Good! You've learned to abstract reality, to be guided less by the literal appearance of things than by what looks best to the eye. The most accomplished artists are those who know when to lay down their pen or brush; and when to add a purely decorative flourish to their artwork. In the final analysis, what looks good is what the public will accept and will like, no matter how much it departs from so-called reality. Peter Arno will paint shadows according to the light source falling on the object, but then draw a shadow on the opposite side, purely for the sake of appearance. And nobody will question it. And why should they? It looks good.

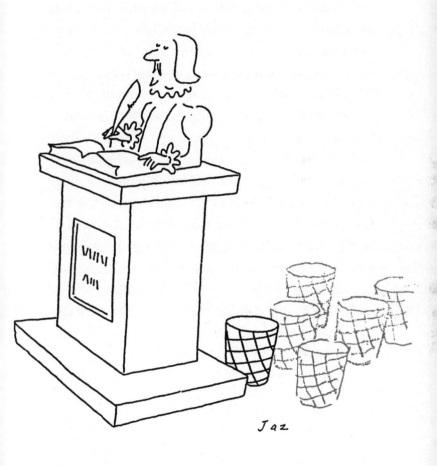

Hyperbole never hurts.

I have only one cavil about your cartoon (and I took the liberty of drawing over it with a pencil, indicating what I have in mind). I would have liked several waste-paper baskets behind the writer. Hyperbole in humor never hurts. Quite the opposite. It's what makes something funny. And it's what punches your point.

Now that I've written this, I have another cavil. I can't imagine that the writer you chose, William Shakespeare, ever slaved over his work. Other writers, yes. But Shakespeare, no. He was Godlike, unique, no more a creative mortal than a Mozart or a Bach. However, on second thought, maybe your choice of Shakespeare was an instance of the very hyperbole I was just recommending, and moreover was a good way of saying "writer." So forget what I just wrote.

Since Christmas is almost upon us, I have to go wrap presents and prepare cards. Thank you for your card. Signed by Emily, too. Hmmm!

> All best wishes to you (and Emily)
> in the coming year,
> Bob

P.S. I wrote that Mozart was no "creative mortal," but let him have the final word on that. I recently

attended a concert where the program notes quoted him. "People err who think my art comes easily to me. I assure you, dear friend, nobody has devoted so much time and thought to composition as I. There is not a famous master whose music I have not industriously studied through many times."

That said, he *still* was a genius, albeit a hardworking one. But the two are not incompatible. "Genius is hard work," wrote Gertrude Stein.

November 12, 1984

Dear James,

Let me tell you about a job that came in last Friday. It came in late, just as I was about to have dinner— and believe me, that's late! My dinner hours are positively Spanish. "Please call me when you can," a fax read. "I need to have an illustration for a Science column and the deadline is Monday!" Along with this request—or was it a plea?—came the article.

Now did you catch that fax's exclamation point? Clearly the art director was concerned whether I could take the job or not, and just as clearly she had not been able to find another illustrator. Her back was against the wall.

I assured her that, yes, I could and would take the job. The deadline didn't throw me, although I would have liked a weekend free of work. But the article intrigued me. It was about how time is experienced by us earthlings, pulsing to our circadian beats, and how it is experienced in a universe that ranges from to microscopic nanoseconds to trillions of light-years.

I did my sketch that night, faxed it to her in the morning, and received a telephone call. "Great! I love it!" (Now those are exclamation points I relish.) Great, indeed. There I was, pen in hand, ready to stroll down Easy Street. But not right away. I would first finish reading a book I had begun a week ago.

The book took me into the middle of the next day. Sunday. It was time (that word!) to put the book aside, pick up my pen, and redraw the rough sketch as a finish.

My sketch, I should mention, showed Father Time, scythe in hand, wide-eyed in a landscape of hourglasses of the most varied sort—tall, thin, squat, giant, tiny . . . my metaphors for the different ways time is measured.

I took my sketch, placed it on a lightbox as a guide, and then started to draw the finish. Drawing Father Time was a breeze. He was something of a stock figure in my repertoire. Then, after two or three passes, I drew suitable hourglasses. So far, so good, no problems. But when it came to drawing the sand, my pen hesitated. Would I have to draw every grain of sand in those hourglasses, or could I treat the mass of sand stylistically? And would the look of the sand grains—their size and shapes, perhaps their colors—differ according to the varied sizes and shapes of their containers?

I tried different approaches, but everything I did looked fussy and unconvincing—and sand distracted from the point of the drawing. The focus had to be on the different shapes and sizes of the hourglasses, nothing else. But who ever heard of hourglasses without sand?

I was getting worried. Time—that preoccupation of the art director, which I now shared—was running out. (Oh, the ironies of this job!)

I then drew the hourglasses without sand, but since they looked bare—and *blah*—I added highlights, treating the glare decoratively. Now the drawing looked good. But would anybody miss the sand?

"Moisha," I asked my wife (that *is* her name, and don't ask me why—she isn't even Jewish), "do these hourglasses look all right to you?"

"Sure, they look fine to me."

"They *do*?"

"Why not? They look fine. And the drawing is nice. I like it."

"It *reads*?"

Her eyebrows lifted. "Bob, I told you. It's fine. It reads perfectly well. Father Time is looking at a bunch of weird hourglasses."

Success! I would send the art director my drawing

on Monday morning, and maybe get to finish my book that night.

The next day I faxed the drawing, and shortly afterward received the art director's call, "Great! We'll run it in tomorrow's paper."

Now, why do I tell you all of this, James? Here's why. If I had felt obliged to render that sand literally (the pull to render things literally is so strong!), both my drawing and my idea would have suffered. Instead, as it happened, the drawing was improved by adding the decorative flourishes of the highlights. Moreover, the glare justified the missing sand. (And who would have guessed it going into the drawing? Not me.)

Moral (and there is one): Approach drawings more with your eye than your head. The meaning will invariably fall into place.

Now it's well into the evening. Time (that word again!) to read the Sunday *Times*. But maybe not . . . not before going to bed and trying to sleep after reading that article about our government's covert operations in Nicaragua. Can you believe it? Selling arms to Iran—Iran, of all places!—to release our hostages; and then using the profits from the sale of our weapons to finance the terror squads of the Contras against the legitimate government of Nicaragua. And all this is done covertly by our

government despite an explicit congressional ban. But did I say *our* government? No, it's *their* government. It's *theirs* if it's secret. So maybe I'll just skip the *Times* tonight if I want a good night's sleep. But not tomorrow, not on Tuesday. That's when my sans-sand hourglasses will run (and let's hope my drawings are nicely laid out).

All best wishes,
Bob

P.S. Here's what I sent. It's in black and white, of course. My Xerox doesn't print color.

rk Strange: Making Sense of Time, Earthbound and

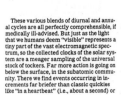

age
cipped
our
k of

more
since the
years
counters
human
ing in
ding up
le
ughs
at may
till
rity of

other
work-
ample,
com-
almost
e are, it
ts own.
in just
d a half
ear,"
sun has
enheit,
urns as
de-
Pluto.

These various blends of diurnal and annual cycles are all perfectly comprehensible, if medically ill-advised. But just as the light that we humans deem "visible" represents a tiny part of the vast electromagnetic spectrum, so the collected clocks of the solar system are a meager sampling of the universal stock of tockers. Far more action is going on below the surface, in the subatomic community. There we find events occurring in increments far briefer than classic quickies like "in a heartbeat" (i.e., about a second) or

"in the blink of an eye" (a tenth of a second), and down into the realms of scientific notation blessedly leavened with Marx Brothers nicknames — intervals like the attosecond (a millionth of a trillionth of a second, or 10^{-18} second), the zeptosecond (a billionth of a trillionth or 10^{-21} second) and, my personal favorite, the yoctosecond (a trillionth of a trillionth, or 10^{-24} second). No matter the nomenclature; the duck soup is ever astir. The time it takes a quark particle to circle around inside the proton of an atomic nu-

cleus? Midway between zepto and yocto, or roughly 10^{-22} second. For an electron to orbit the proton to which it is madly, electromagnetically attracted? A not-quite-atto-sized 10^{-18} second.

Fleeting does not mean flaky or unstable, however. To the contrary: the fundamental quivers of the atom "are exceedingly regular," Dr. Jaffe said, adding, "They mark the heartbeat of the universe." Atomic events are so reliable, so like clockwork in their behavior, that we have started tuning our

macros
and our
fraction
linked to
Or loo
unspeak
race. Co
the twitc
bound ar
galaxies
in define
them ex
flating b
ward fro
years, si
kaboom
clocks ti
dispersa
lions of y
We ar
and hom
um and a
may be t
to us, or
that wha
may be c
zepto ba
home, ar
tinkering
may wel
ours, not
dressed i
taking it
closely y
that soun

December 21, 1984

Dear James,

So you were in *bella Italia* for 5 weeks, and since you've returned, no calls? Welcome to the freelance life! Out of sight, out of mind. But that's the trade-off for living a little, for not having a desk job with its set vacations. However, I assure you, that phone will ring again, and it may not be your mother asking why you haven't called in weeks.

F. Scott Fitzgerald once bleakly opined that in America—I'm going to paraphrase him—there are no second acts. All right, your first act was that 5-week jaunt. And now you're waiting for the curtain to rise again with an audience apparently seated elsewhere. I have news for you. There *are* acts to follow. Second and third and so on and so on and so on. Good happenings and bad, nice surprises and rotten, they move in and out like the tides—except in their own, totally unaccountable, rhythm. The important—the necessary—thing is to keep your head above water, and your eyes fixed landward.

The problem with being a freelancer in any of the creative fields is that taste changes, and with it styles. In our field, art directors and creative heads are always on the move—in one day, out the next—and the new guy wants to put his stamp on the job by finding something and somebody fresh on the page. Not always the worst thing. After all, the point of any drawing is to be looked at, and if it's something you have seen before—and seen again and again—the ho-hum factor kicks in, and that most dreadful closure takes place: a page, barely glanced at, is quickly turned. (I've even done that with one of my favorite artists: Steinberg. I once caught myself all-too-quickly flipping over a spread of his *New Yorker* drawings. Been there, seen that. But Steinberg, it seems, feels the same way about his own work. He can be bored with his own stuff, so he'll move to another look, another medium, always one step ahead of his audience.)

Anecdote: An art dealer once went to Picasso to authenticate a painting. "It's a fake," Picasso declared. "Aha!" rejoined the dealer. "Caught you! I happened to be in your studio when you painted it." "That may be," Picasso replied, "but I often paint fakes."

I suppose any artist with a shtick paints fakes.

Now I've gotten far afield of the point of my letter,

second acts. You'll have them, despite the jealousy of your colleagues and art directors. (Gore Vidal once confessed, "Whenever a friend succeeds, a little something in me dies.") Jealousy, you'll learn, is a powerful and underestimated force in our all-too-competitive lives. You'll have your second acts despite all the new kids on the block who want whatever is the newest and the latest. (NEW! NEW! NEW! blast so many ads, leaving plain old "Good" smoking in the rubble.)

You'll survive, you'll be all right, if you just keep drawing and, yes, hustling (discreetly), while waiting for that curtain to lift, for that telephone to ring. It will.

As ever,

Bob

September 8, 2008

Dear James,

Can it be? Twenty-four years have passed since we corresponded—several lifetimes, it seems—a thousand thousand thousand dizzying turns by that Goddess of Fortune. And here I am, writing you from upstate New York. And there you are, reading this in San Francisco, a married man (so you did work things out with Emily, after all!), and you are a successful illustrator. Congratulations on your August cover—a good one—in *The New Yorker*!

And me? You ask about me. Well, wait a bit. Before I answer, I have to write that I'm so glad you looked me up on the Internet. But for God's sake you didn't have to write, "Do you remember me?" How could I possibly have forgotten that brief and intense correspondence we had?

Now to answer your question, how am I and how am I doing?

Let's go back to that Cold Water Castle of mine. Remember? Quarter-sawn oak paneling . . . vaulted

ceiling . . . walk-in fireplace . . . carved reliefs of the four rivers of paradise adjoining four water sprinklers . . . ?

That was my studio two decades ago, and if you've followed my career since those days, you'll know that I've had quite a few fifteen-minute bursts of fame. Yes, my film *L'Histoire du Soldat* was screened, and yes, it was well received. And yes, I produced many dozen award-winning commercials (but—damn!— almost as many proposals for unproduced features, all gorgeously packaged. Take a look—I'm enclosing one of the presentation covers. This was for a film that almost got made. For nearly a year, Charlie Watts, the Rolling Stones drummer, and I had talked of collaborating on an animated feature about Charlie Parker.). And yes, I painted more than a dozen covers for *The New Yorker* (now serving as wallpaper for I-don't-know-how-many smart bathrooms in New York City). So yes, yes, yes—wallpapered bathrooms and unproduced features aside—it has been a long and successful run.

But that was then.

In the late nineties a harbinger of change—radical change—appeared on the terrace of my studio. It was an augury, but one I ignored. In Darwinian fashion,

street sparrows began to displace the family of house finches that had long been the sole occupants of my terrace. Soon the melodic singing of songbirds was replaced by the screeching and scrapping of street birds who had found better and steadier lunches than on the sidewalks of New York.

What I witnessed on my terrace I was to increasingly experience in the workplace. It seemed that newer and more aggressive styles of art were replacing mine. Moreover, my style of drawing, variously described as wiggly, squiggly, or nervous, was becoming generic. Work that people could swear was mine, I had never done. If imitation is the sincerest form of flattery, it was also the shortest road to the poorhouse.

For almost a quarter-century my studio had housed an animation facility, The Ink Tank. Among its productions were *Simple Gifts* and, of course, *L'Histoire du Soldat,* as well as material for Sesame Street and the CBS and NBC networks. These had been the caviar on our plate. The bread and butter were the commercials, often requested in the Blechman (but increasingly "Bleckman," and occasionally "Belchman") style. The studio had been a flourishing enterprise, but the George W. Bush years saw a collapse in advertising and

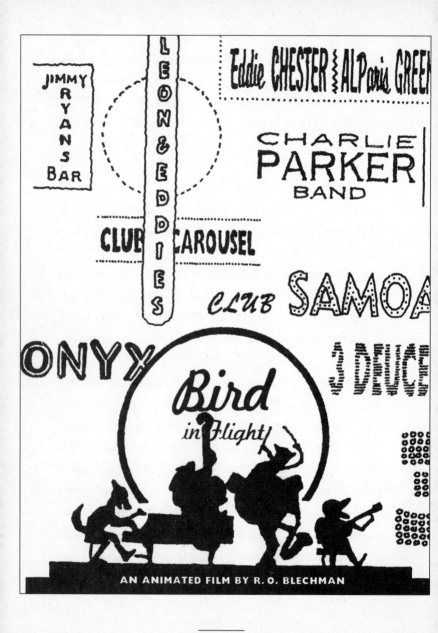

AN ANIMATED FILM BY R. O. BLECHMAN

fewer requests for Ink Tank animation. Soon it became apparent that I did not need seventeen telephone lines and did not require two floors of studio space—or even one. The loss of a major client, and the complications that followed—don't ask!—sealed the studio's fate. It was time to move. On, I hoped—upward, if possible— to new ventures, or to old ones previously neglected. I had a property upstate with a large studio, and that is where I moved. Seventy years of city living had come to an end.

Did I mind? Yes and no. Yes, my studio was dismantled, like a venerable oak chopped up for firewood. Even the heart of the studio—the main room and the adjoining private office of Bertram Goodhue—was divided among tenants. The building that had once housed eminent architects and interior decorators—Elsie de Wolfe had occupied two floors for her studio and showroom—now became a warren of jerry-built spaces occupied by jewelers and small manufacturers speaking a Babel of tongues. "Op?" I heard one passenger ask another on the elevator. "Oop," came the reply.

Once, I saw a tenant, newly arrived from the Near East, squatting by a fire on the naked floor (concrete, thank God!), smelting a bar of metal.

And yes, I did mind leaving another kind of aerie—my spacious apartment overlooking Central Park from turn-of-the-century cast-iron balconies.

But no, I did not mind moving to a country aerie overlooking the Berkshire foothills. I did not mind waking up to the sound of birds instead of cars. I did not mind hearing indignant frogs croaking as I approached my pond (well, *our* pond) for my daily swim.

So, James, I did not so much lose aeries as change them. And what has not changed—wrinkles aside—was me. Can an artist ever retire? Can he stop doing what has so largely justified his existence? Can arthritis of his hands stop a Renoir from painting? No, somebody will strap a brush to his arthritic hand. Can David Levine, eyesight weakening, stop drawing? Absolutely not. He will put aside his pen and replace it with a pencil. And he will continue to draw—draw and paint—weakened eyesight be damned!

Fortunately arthritis or weakening eyesight are not my problems. If I have a problem, it's that some nights I wake up with a start when an idea—*ping!*—has brightened my darkened mind and compels me to go to that alternate studio, my bathroom, which these days I have to use more anyway. That seems to

be my one problem, and if it's the worst I have, it's one I wish on any artist my age.

So here I am—anno 2008—not entirely of this age, a rather square analogue peg in a very digital world. But my digital connections are cerebral—interior, not exterior—a better placement, wouldn't you say? But tell me. Tell me. Tell this 78-year-old whose dreams are as fixed and as large and as pressing as those of the 22-year-old who first took pen to paper on a green Formica table. Let me into *your* world. Send me your letters—they will be so welcome—your letters to this old illustrator.

As ever,
Bob

CREDITS

Pages 23–24 W. H. Murray, *The Scottish Himalayan Expedition* (London: J. M. Dent & Son, 1951).

Pages 30–31 T. S. Eliot, "East Coker," *Four Quartets* (Houghton Mifflin Harcourt Publishing Company).

Pages 32–33 Peter Arno, foreword, *Peter Arno's Ladies and Gentlemen* (New York: Simon & Schuster, 1951).

Page 37 Photograph courtesy of Don Hammerman

Page 50 "Road Workers" by William Gropper, courtesy of ACA Galleries, New York

Page 53 Drawing courtesy of the author

Page 75 Drawing courtesy of Nurit Karlin

Pages 84–91 Drawings by the author, courtesy of *The New York Times*

Page 102 Ad courtesy of *Look Magazine*

Page 112 "Hiroshima," 1945 by Saul Steinberg © 2008. The Saul Steinberg Foundation/Artists Right Society (ARS), New York.

ACKNOWLEDGMENTS

The eponymous James is a figment of my imagination, but the drawings are real. They're the work of talented cartoonist Nurit Karlin, a former student of mine. She generously gave me permission to use them for this book. If you don't know Nurit's cartoons, it's my pleasure to introduce them to the larger audience they deserve. One of her books is *No Comment*. It is out of print, but look for it (Charles Scribner's Sons, New York, published in 1978). You're in for a treat.

This book would not have been written if not for a suggestion from my son Max. One evening he told me, "Bob," (we're on a first-name basis), "why don't you write something like Rilke's *Letters to a Young Poet*, but for illustrators?" That order, it turned out, was a tall one. Max, I hope I did it justice.

I want to thank my wife, who first saw this book in a very early state. If she hadn't liked it, if she hadn't given it a Roger Ebert two thumbs up (one thumb would not have done it), this project might have been abandoned.

What gave this book legs was my agent, Alexis Hurley. She brought it to just the right people— people who stuck their corporate necks out in these bottom-line times. Thank you, Colin Fox. And thank you, David Rosenthal. Your thumbs (all four) were the critical ones.

ABOUT THE AUTHOR

R. O. Blechman published his first book, *The Juggler of Our Lady,* in 1953, and went on to work as a freelance illustrator for such publications as *Fortune, Harper's Bazaar,* the *Atlantic,* and *Rolling Stone.* His illustrations have graced fourteen covers of *The New Yorker.* Blechman operated an animation studio for twenty-seven years, producing the Emmy award–winning version of Igor Stravinsky's *L'Histoire du Soldat.* His artwork has been exhibited in New York, Paris, Berlin, and Munich. Among his many honors are his 1999 induction to the Art Directors Club Hall of Fame and a 2003 exhibition of his films at the Museum of Modern Art.